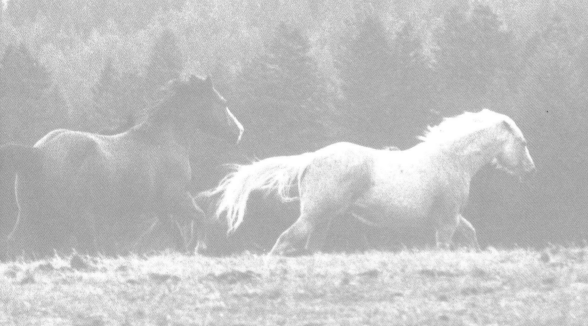

THE Quotable Equine

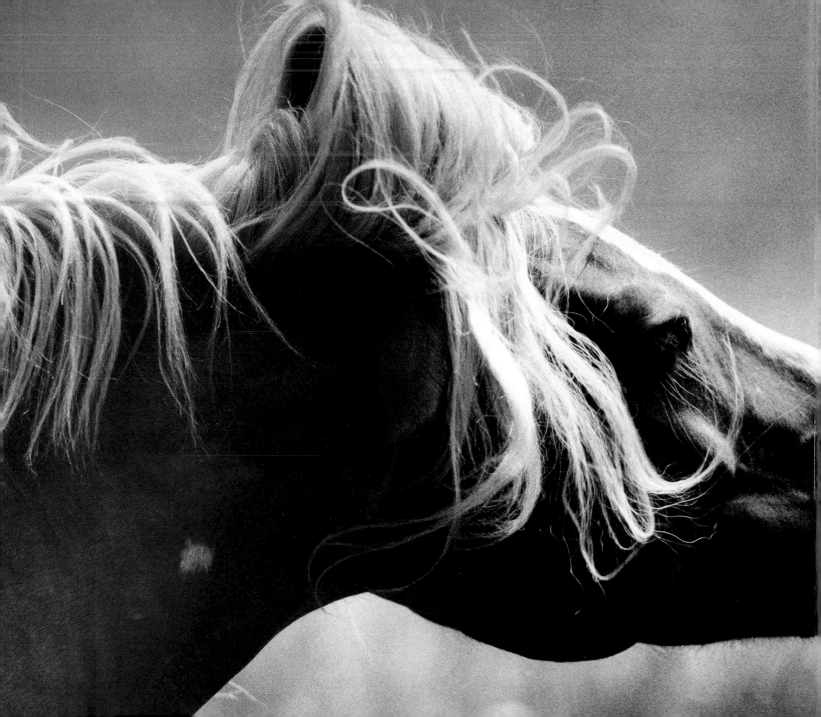

THE Quotable Equine

JIM DRATFIELD

Clarkson Potter / Publishers
New York

Published by Clarkson Potter/Publishers, New York, New York.
Member of the Crown Publishing Group, a division of Random House, Inc.

www.randomhouse.com

CLARKSON N. POTTER is a trademark and POTTER and colophon are registered trademarks of Random House, Inc.

Printed in Singapore

Library of Congress Cataloging-in-Publication Data
Dratfield, Jim.
Quotable equine / Jim Dratfield.
1. Horses—Pictorial works. 2. Quotations, English. I. Title.
SF301.D68 2003
636.1'0022'2—dc21 2002155674

ISBN 1-4000-4870-2

10 9 8 7 6 5 4 3

First Edition

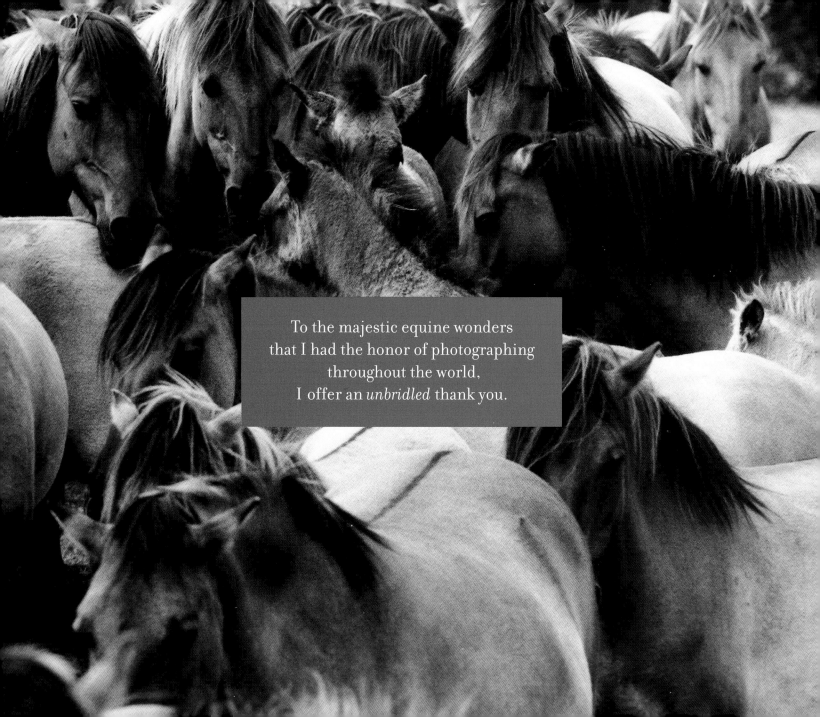

To the majestic equine wonders
that I had the honor of photographing
throughout the world,
I offer an *unbridled* thank you.

A lovely horse is always an experience. . . .
It is an emotional experience of the
kind that is spoiled by words.

—Beryl Markham

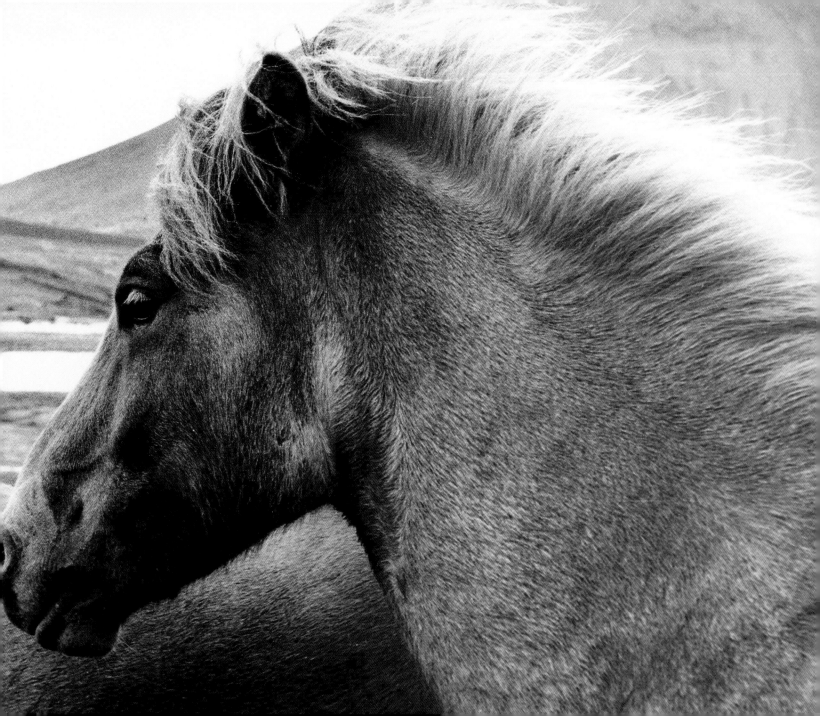

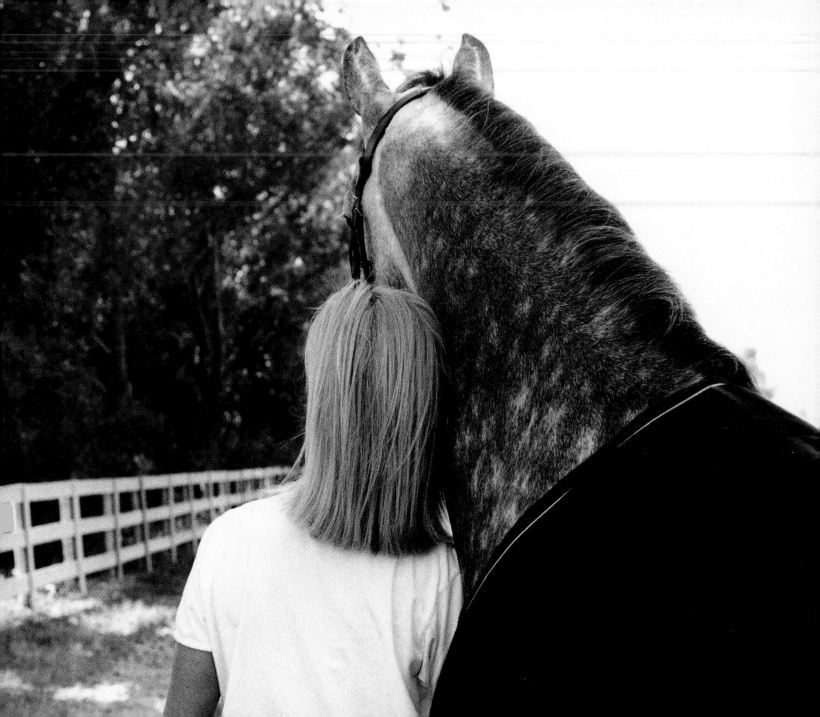

Love does not consist in gazing at each
other but in looking outward together
in the same direction.
—Antoine de Saint-Exupéry

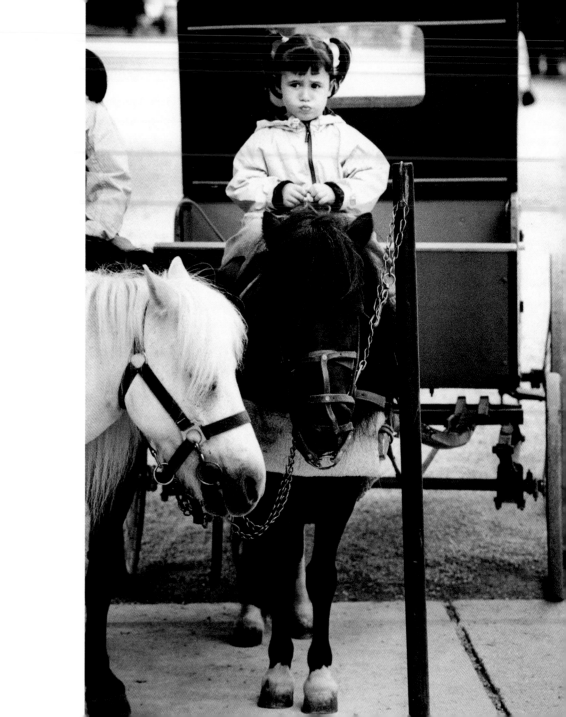

The past cannot be changed. The future is yet in your power. —MARY PICKFORD

The great thing in this world is not so much where we stand as in what direction we are moving.

—Oliver Wendell Holmes

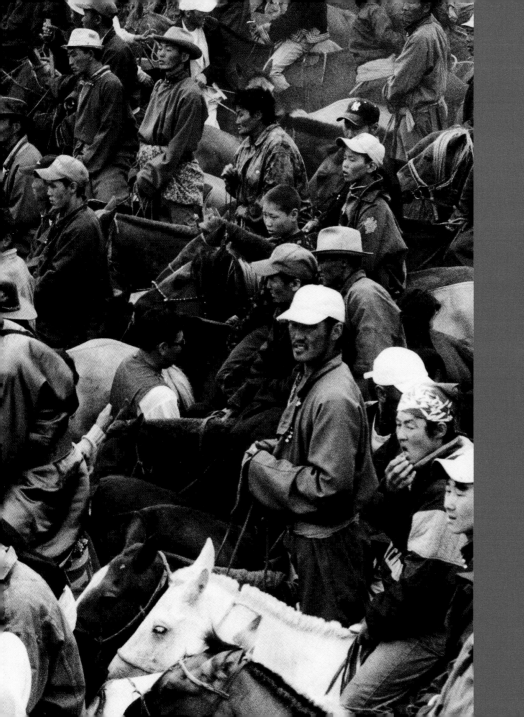

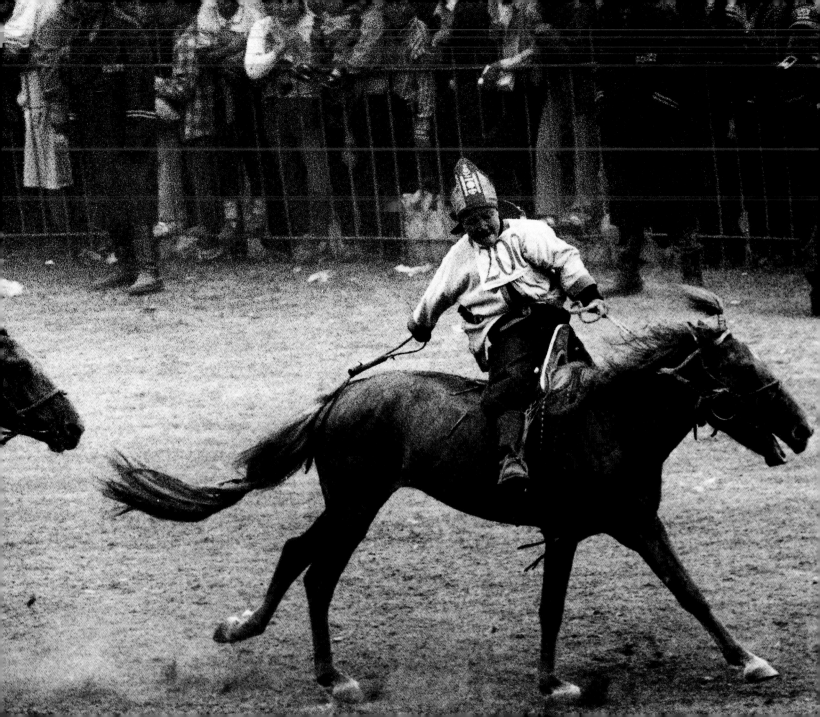

Success is dependent on effort.

—SOPHOCLES

If the rider's heart is in the right place, his seat will be independent of his hands.

—Piero Santini

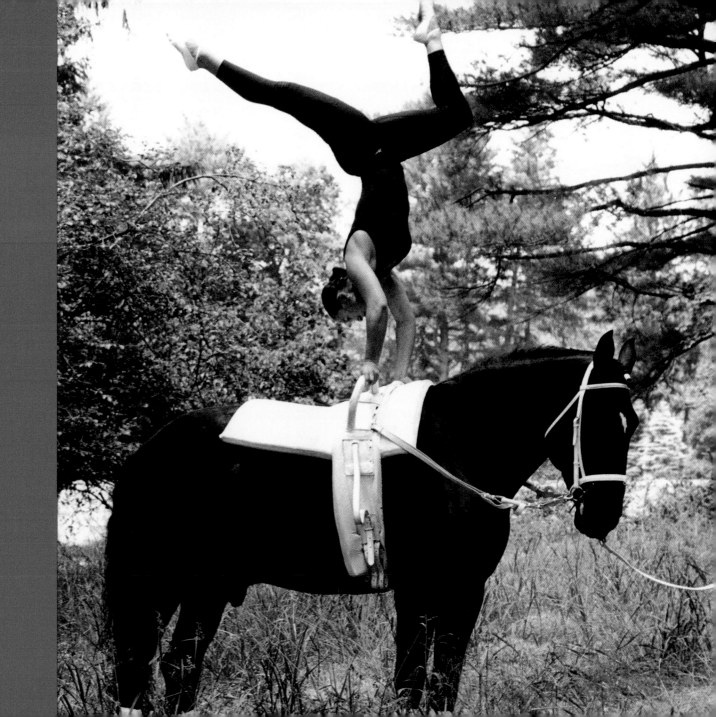

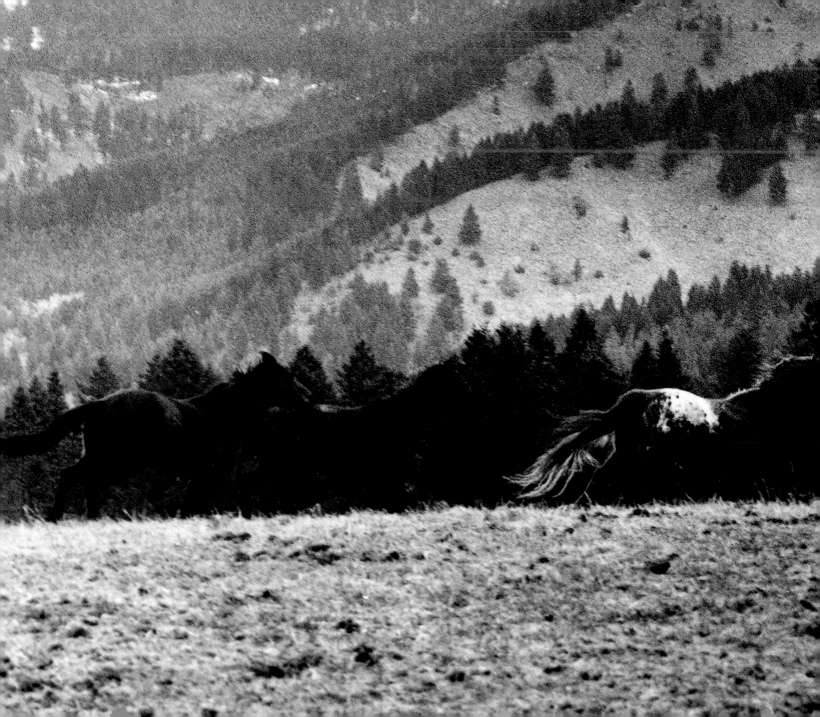

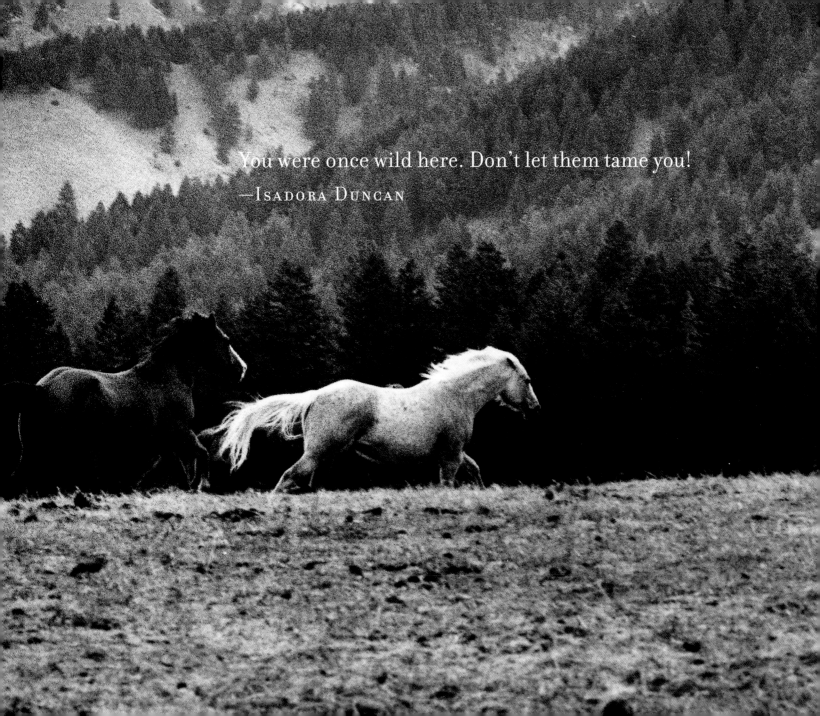

You were once wild here. Don't let them tame you!
—Isadora Duncan

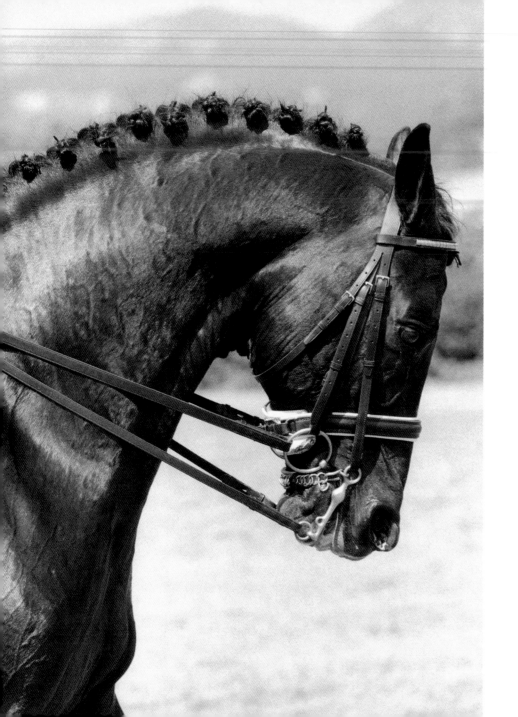

Character is destiny.

—HERACLEITUS

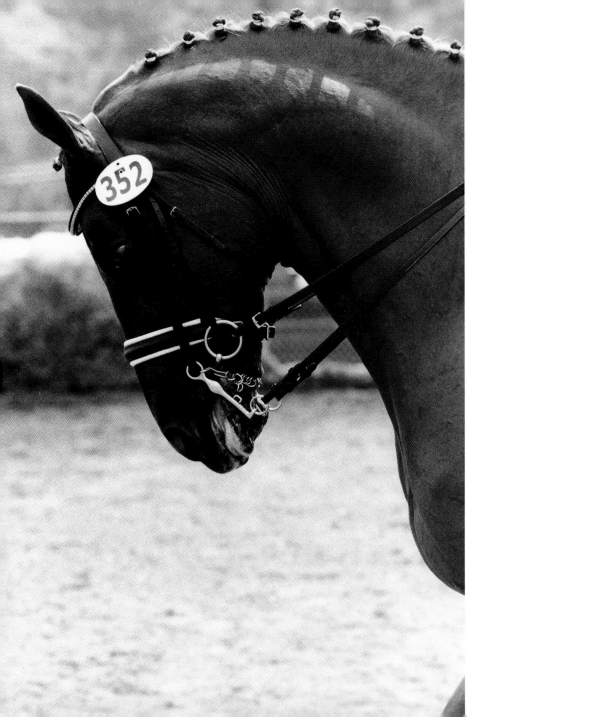

Fashions fade; style is eternal. —YVES ST. LAURENT

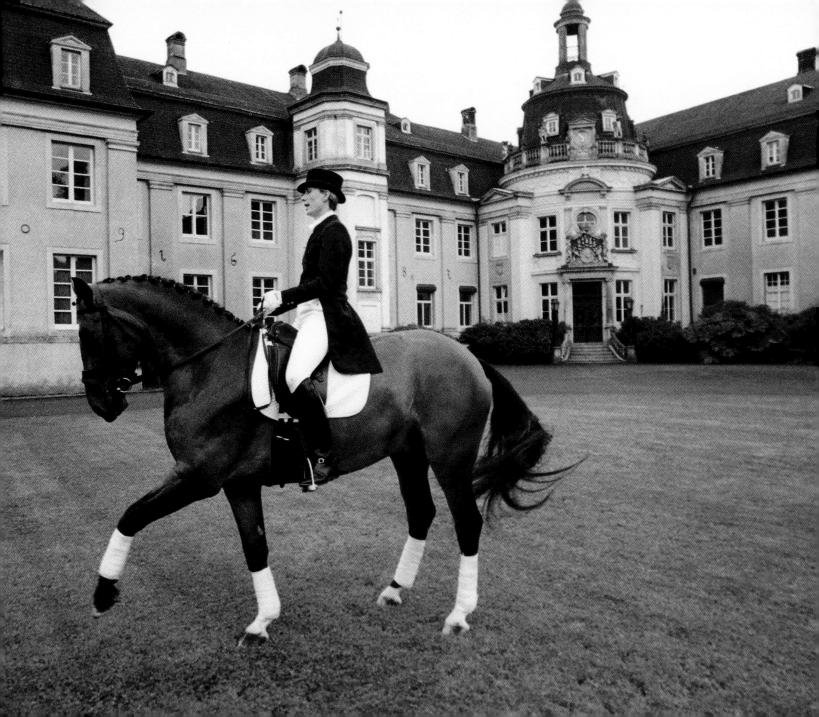

Life is uncertain. Eat dessert first. —Ernestine Ulmer

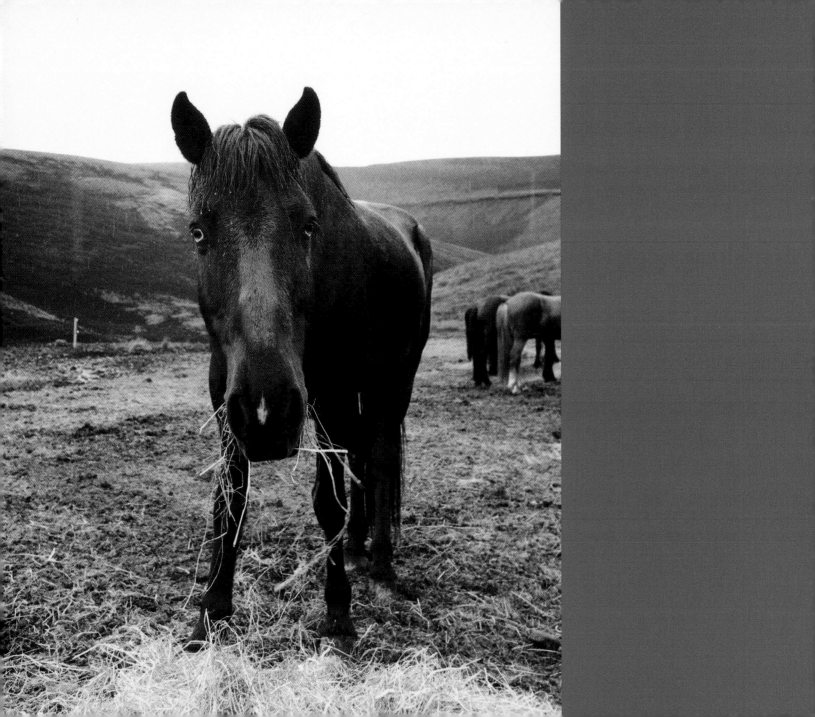

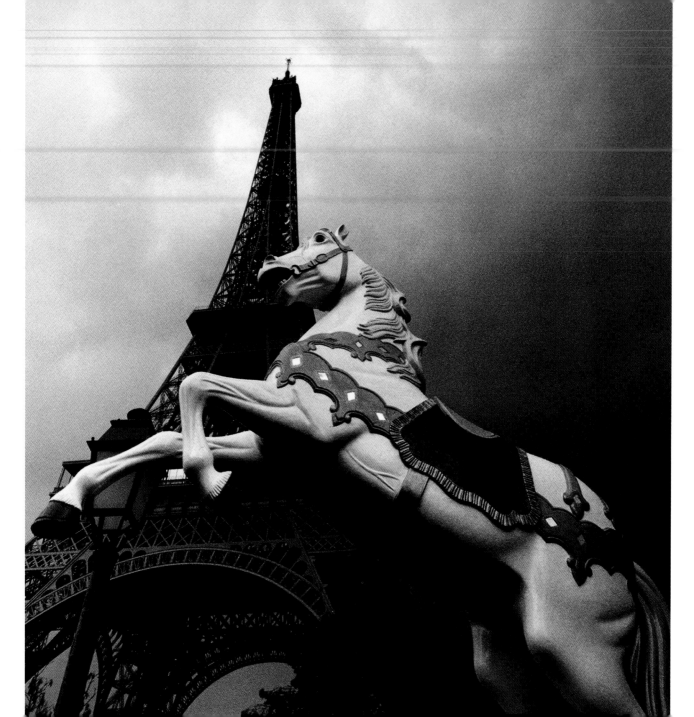

Imagination is the highest kite that one can fly.

—LAUREN BACALL

Only those who dare to fail greatly can ever achieve greatly.
—Robert F. Kennedy

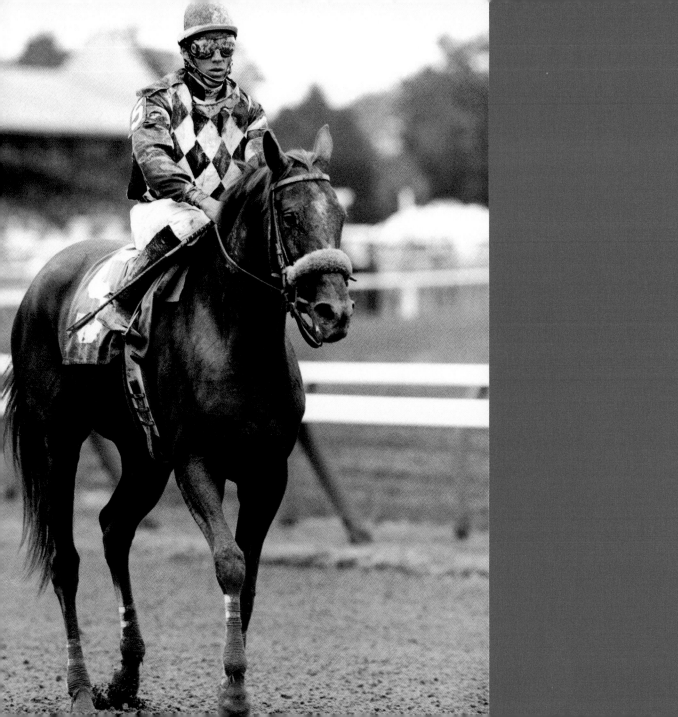

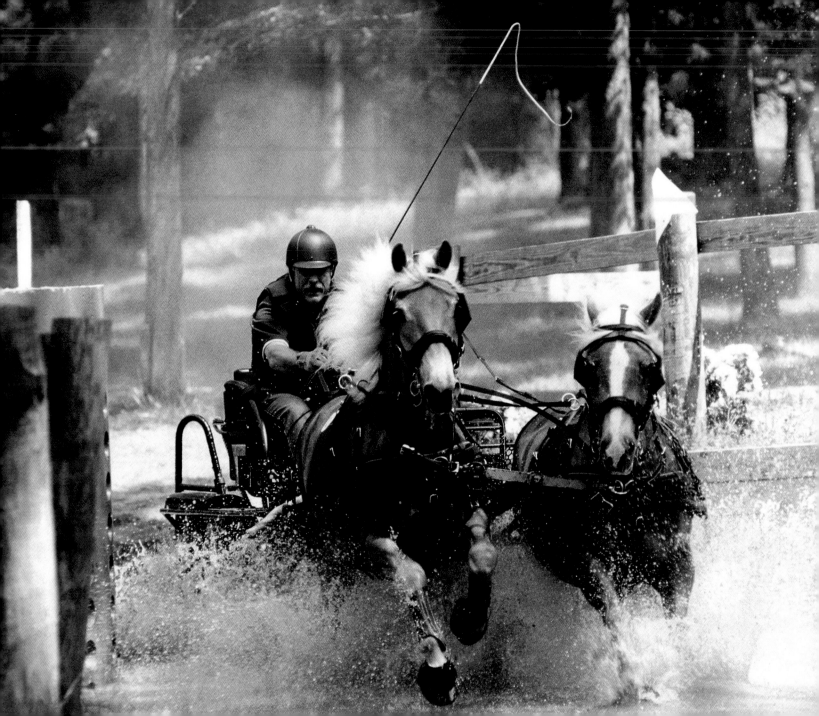

The reputation of power is power.

—THOMAS HOBBES

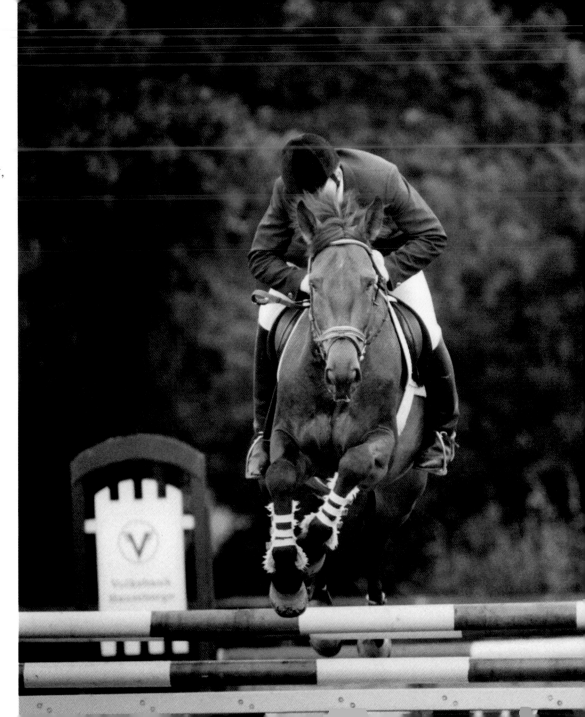

*To seek one's goal
and to drive toward it,
steeling one's heart is
most uplifting!*

—Henrik Ibsen

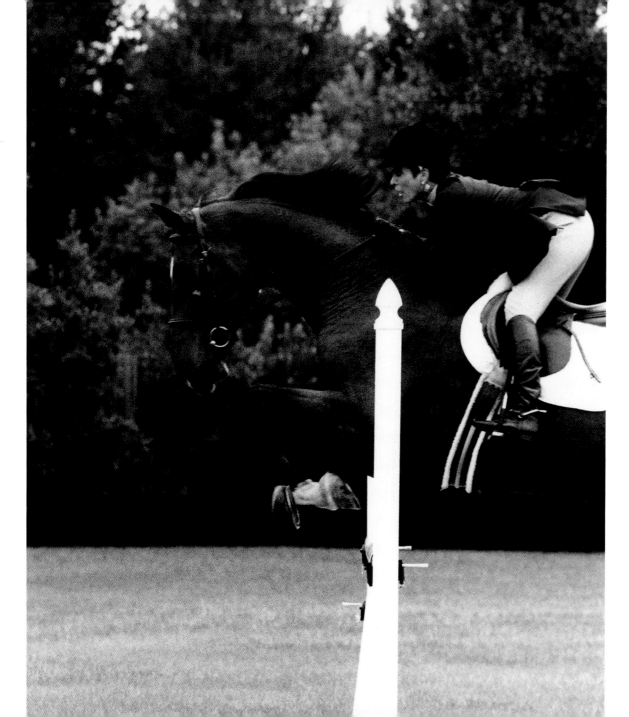

The supreme happiness of life is the conviction that we are loved.

—VICTOR HUGO

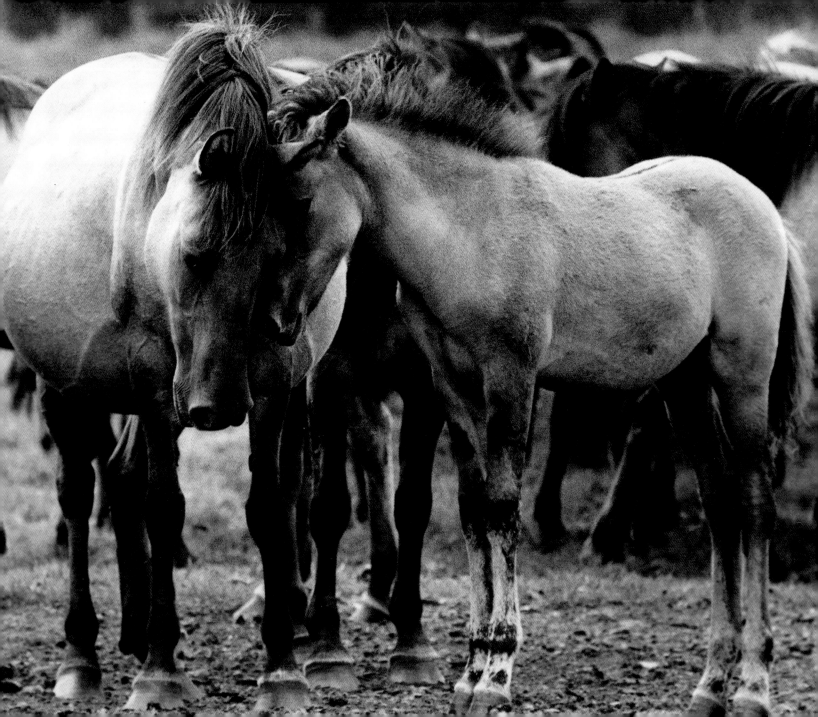

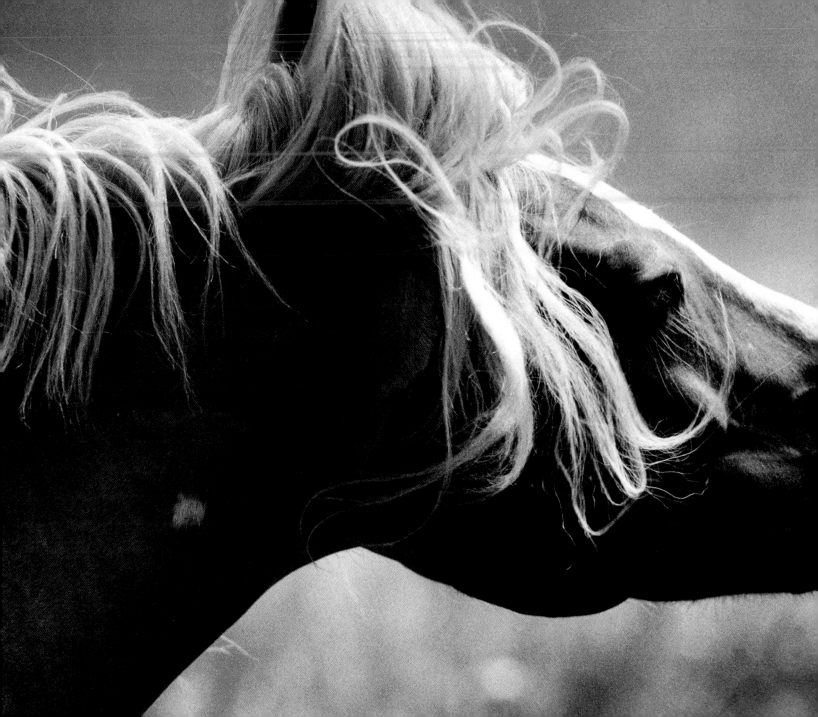

To see what is in front
of one's nose requires a
constant struggle.
—George Orwell

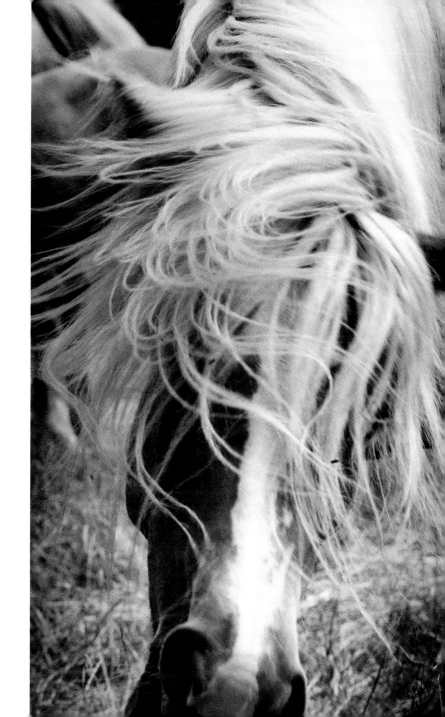

I don't like standard beauty—
there is no beauty without
strangeness. —Karl Lagerfeld

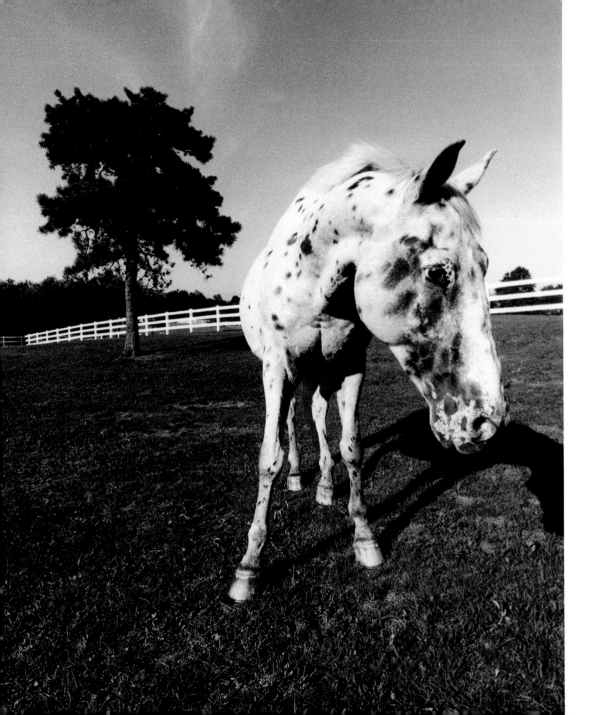

The most beautiful thing we can

experience is the mysterious.

—Albert Einstein

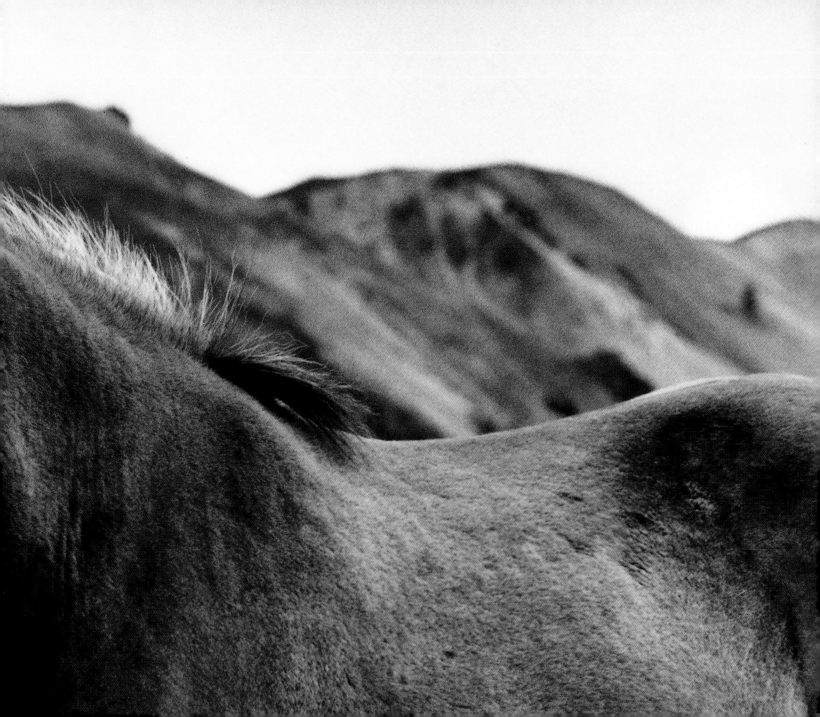

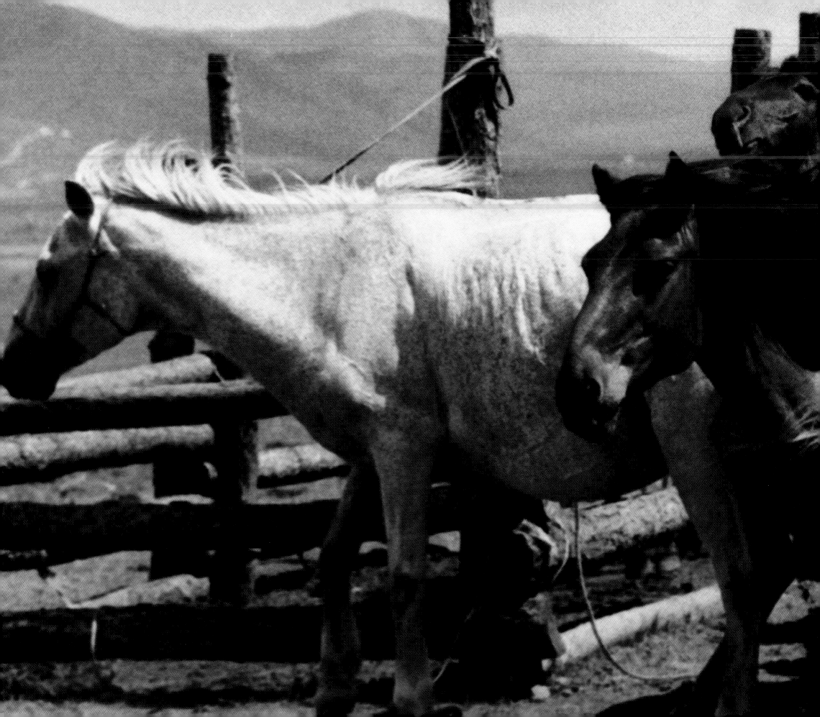

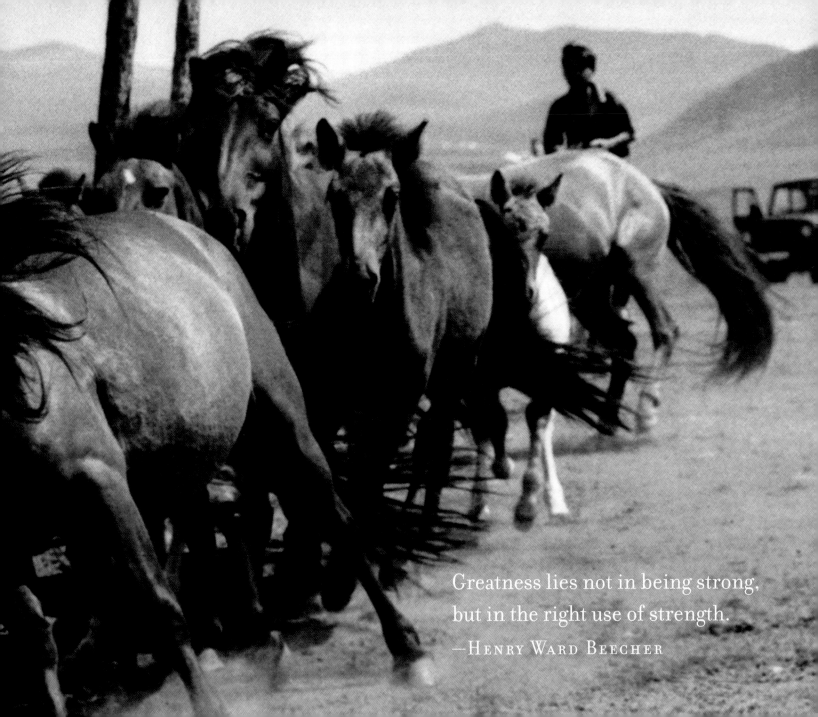

Greatness lies not in being strong,
but in the right use of strength.
—HENRY WARD BEECHER

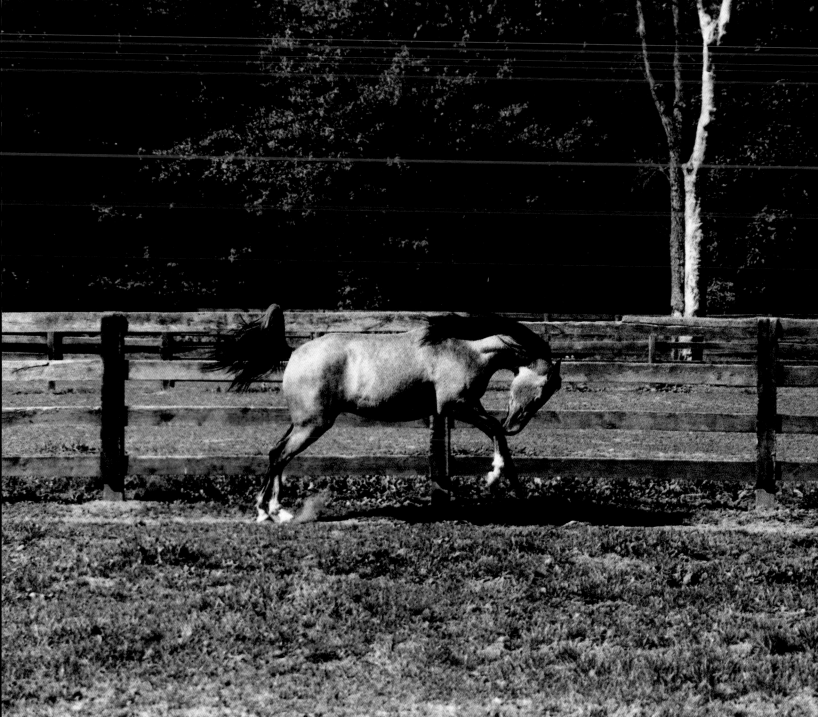

The wildest colts make the best horses. —Plutarch

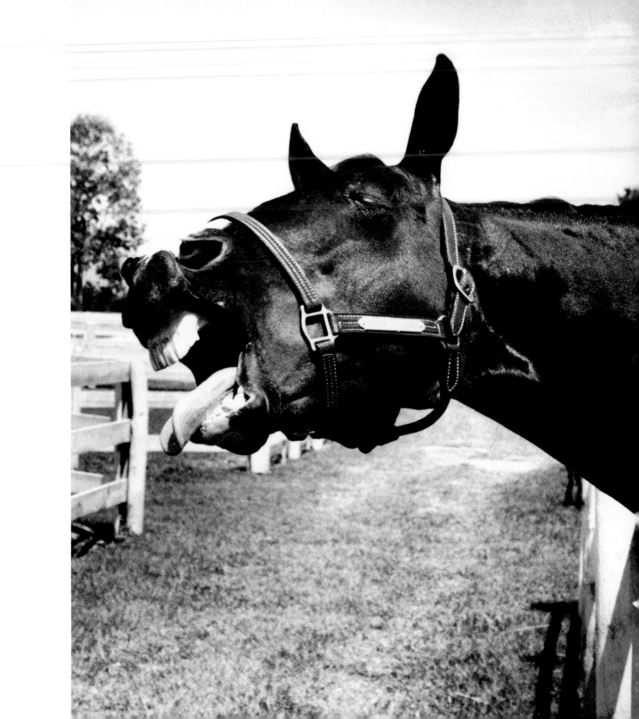

You will do
foolish things,
but do them
with enthusiasm.

—Colette

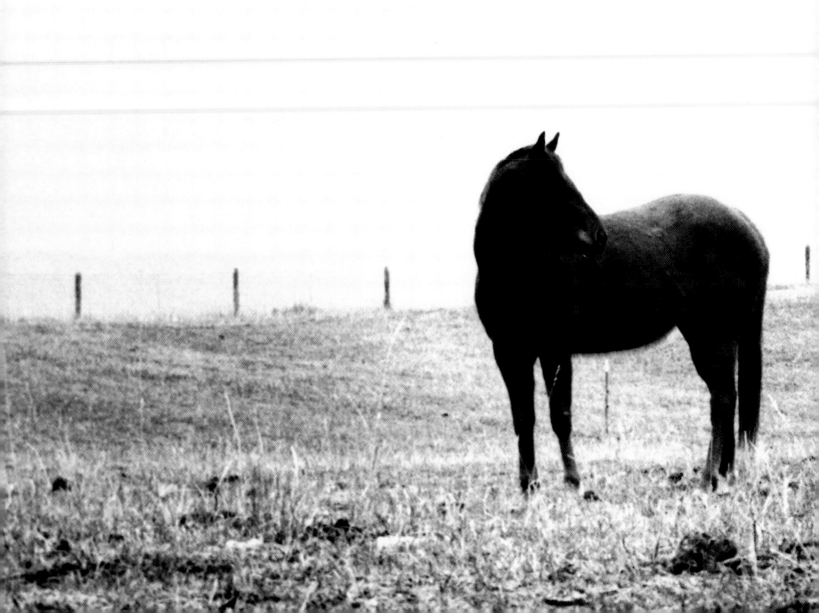

There are friends and faces that may be forgotten, but there are horses that never will be.

—ANDY ADAMS

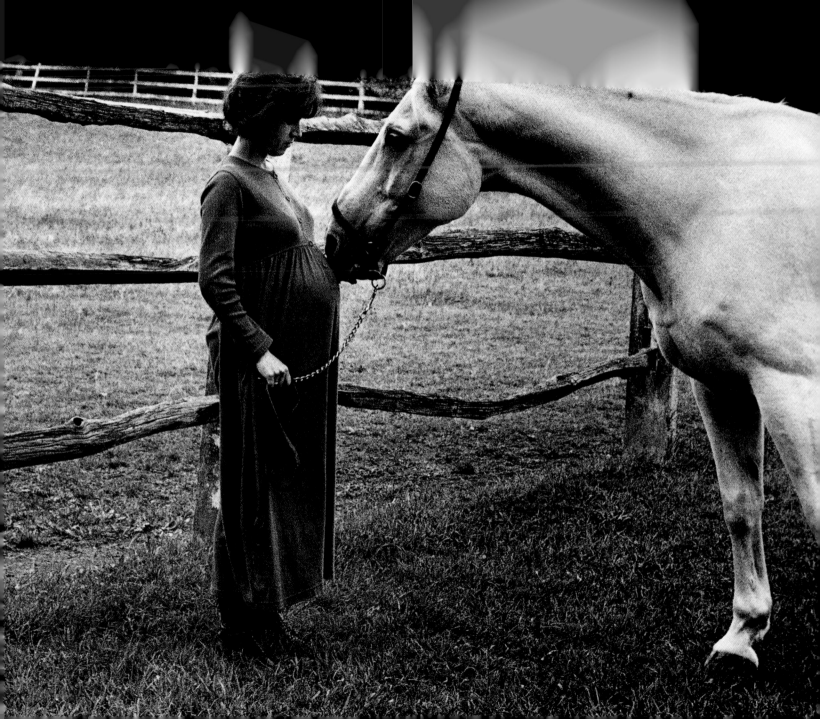

At the touch of love,

everyone becomes a poet. —Plato

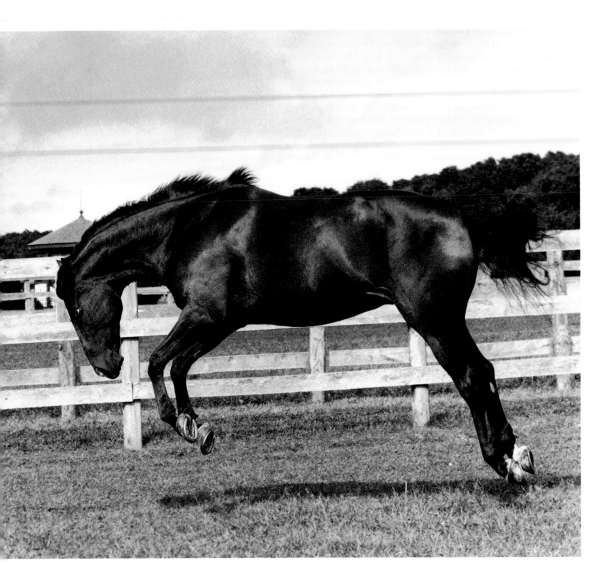

There is
no cure
for birth
and death
save to enjoy
the interval.
—GEORGE
SANTAYANA

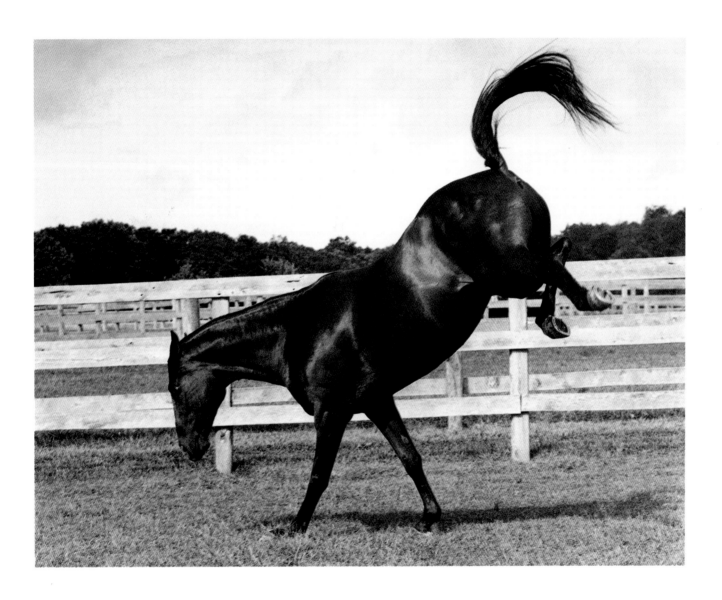

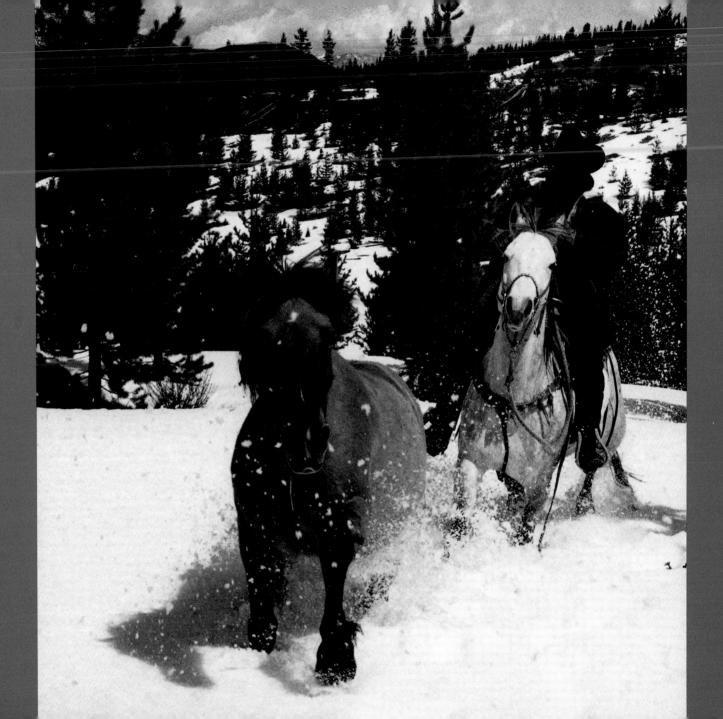

Adventure is worthwhile in itself.

—AMELIA EARHART

I glory in conflict, that I may hereafter exult in victory.

—Frederick Douglass

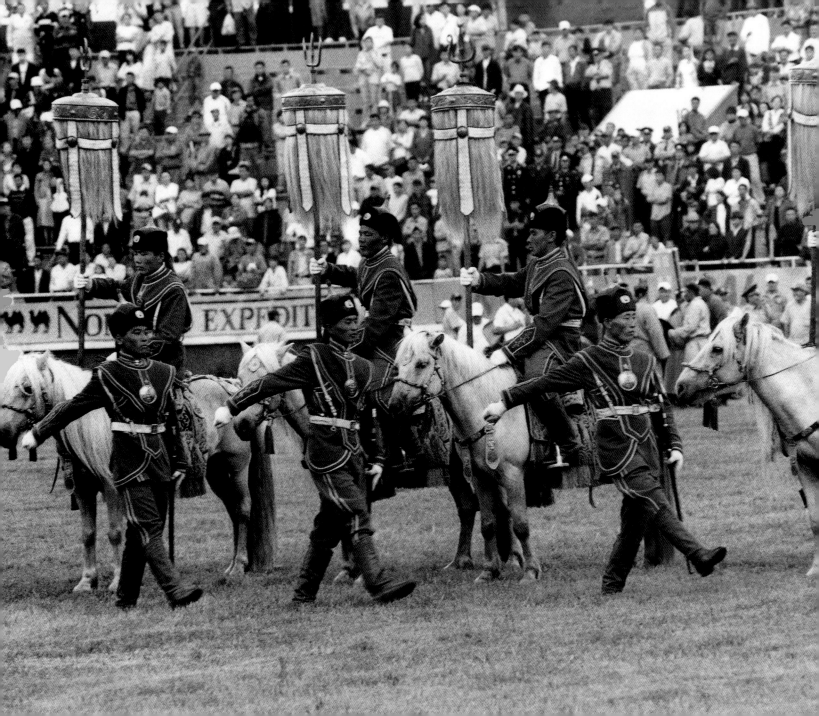

How sweet it is when
the strong are also gentle!
—LIBBIE FUDIM

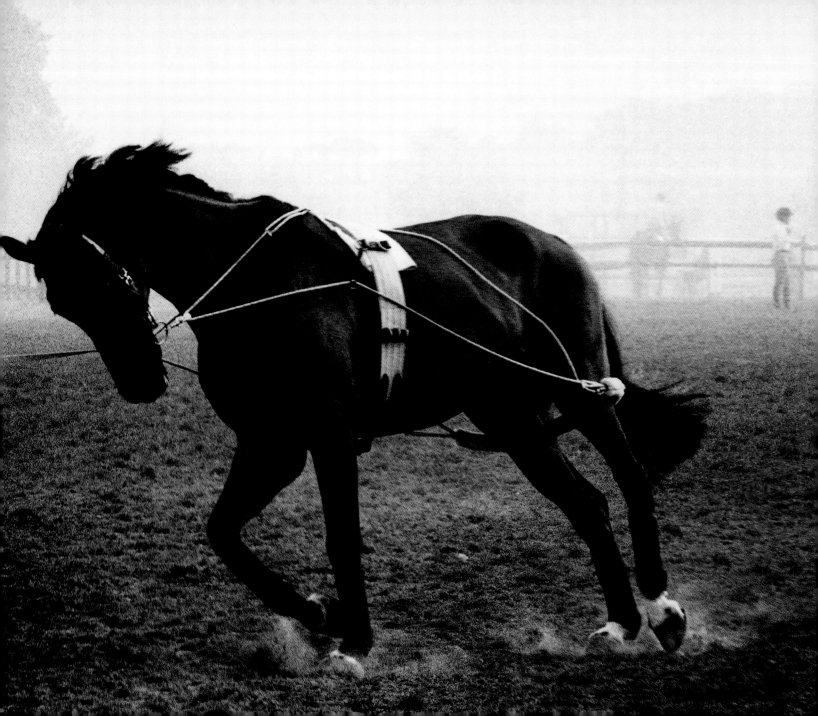

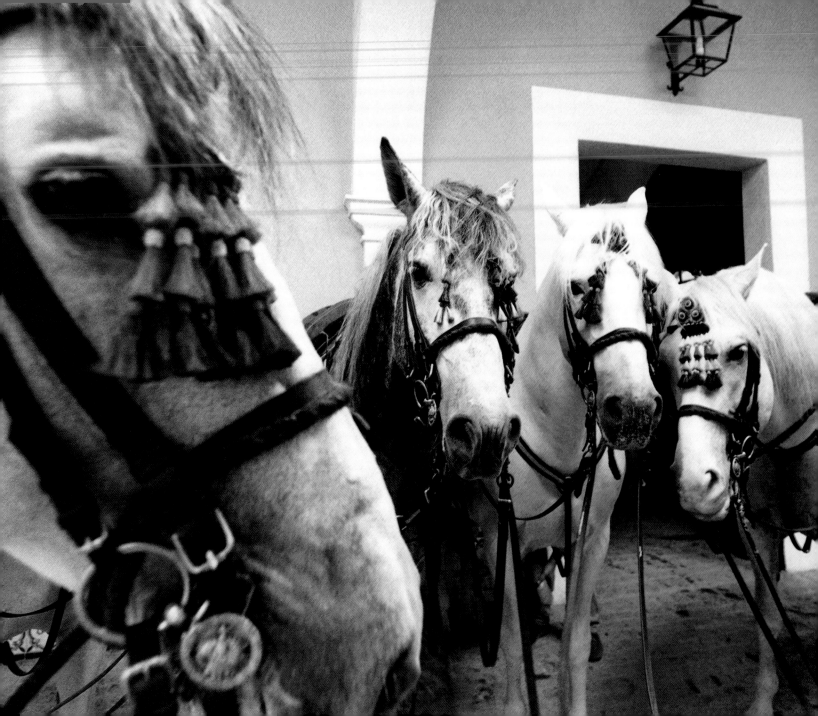

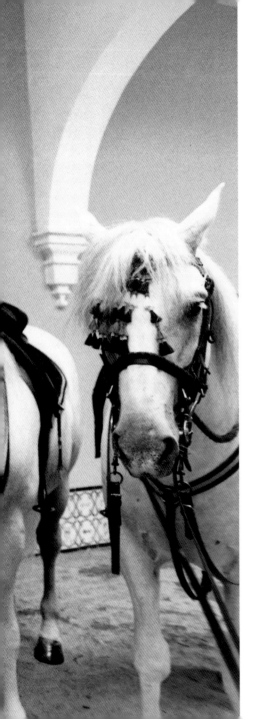

Beauty and folly are generally companions.

—Baltasar Gracián

Start by doing what's necessary, then what's possible,
and suddenly you are doing the impossible.
—St. Francis of Assisi

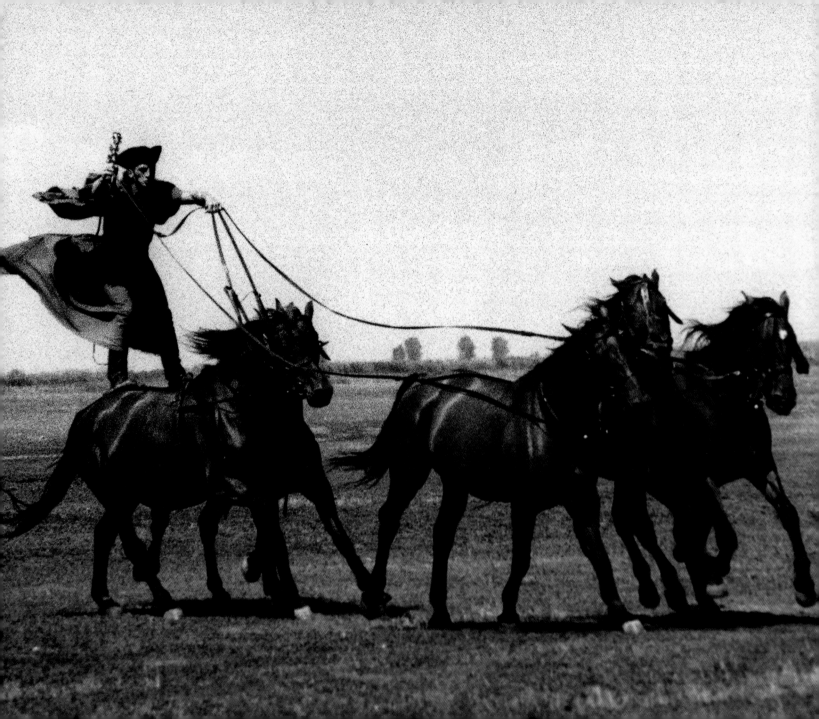

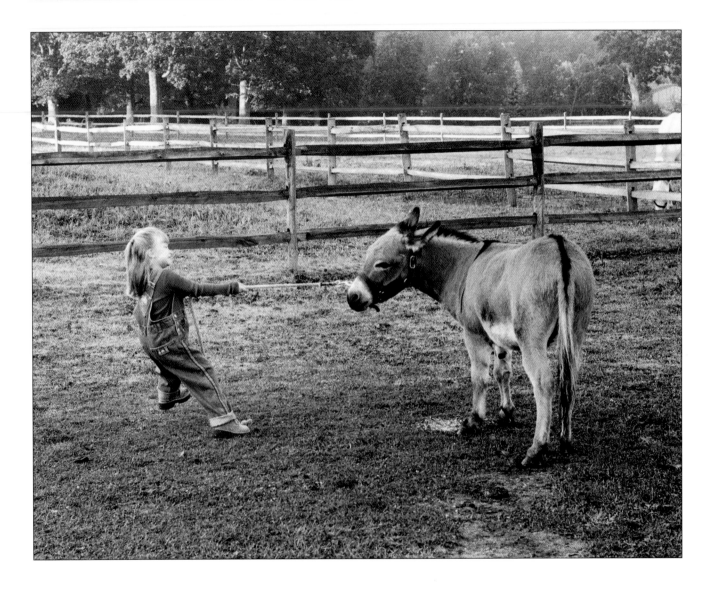

Many are stubborn in pursuit
of the path that they have chosen,
few in pursuit of the goal.

—FRIEDRICH NIETZSCHE

The great cowboys
are the ones with
the biggest hearts.
—Ty Murray

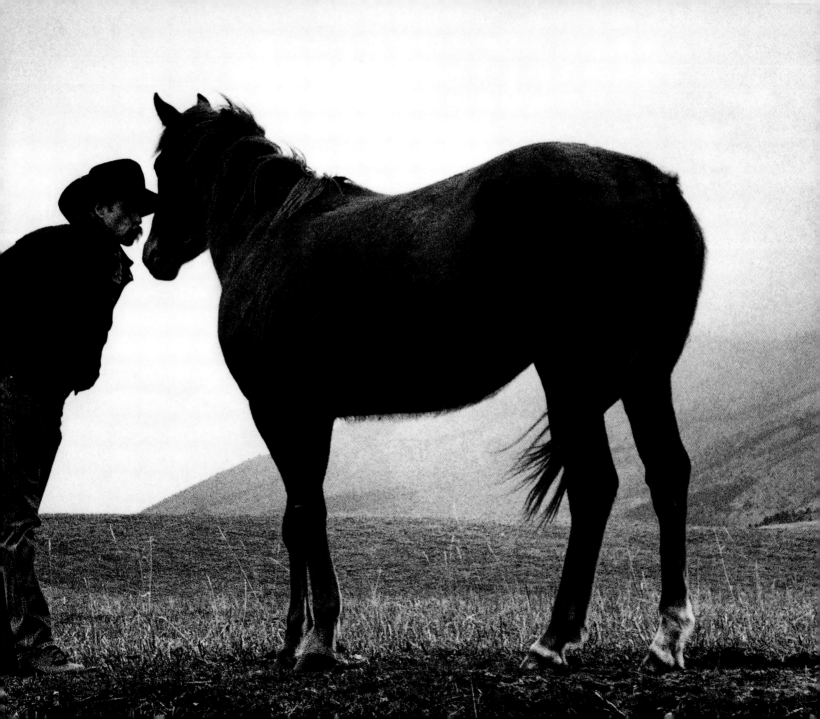

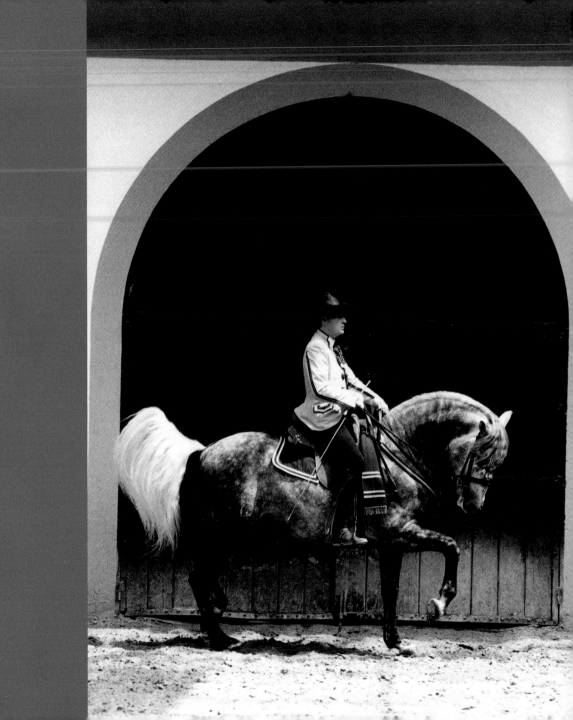

Elegance is innate. . . . It has nothing
to do with being well-dressed.

—DIANA VREELAND

O for a horse with wings . . .

—WILLIAM SHAKESPEARE

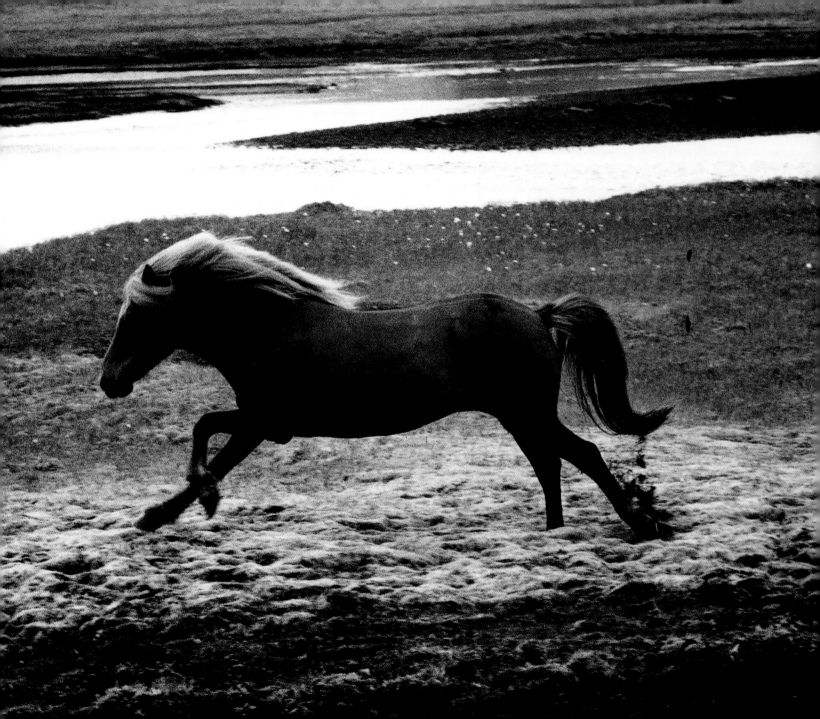

There is nothing like staying

at home for real comfort.

—JANE AUSTEN

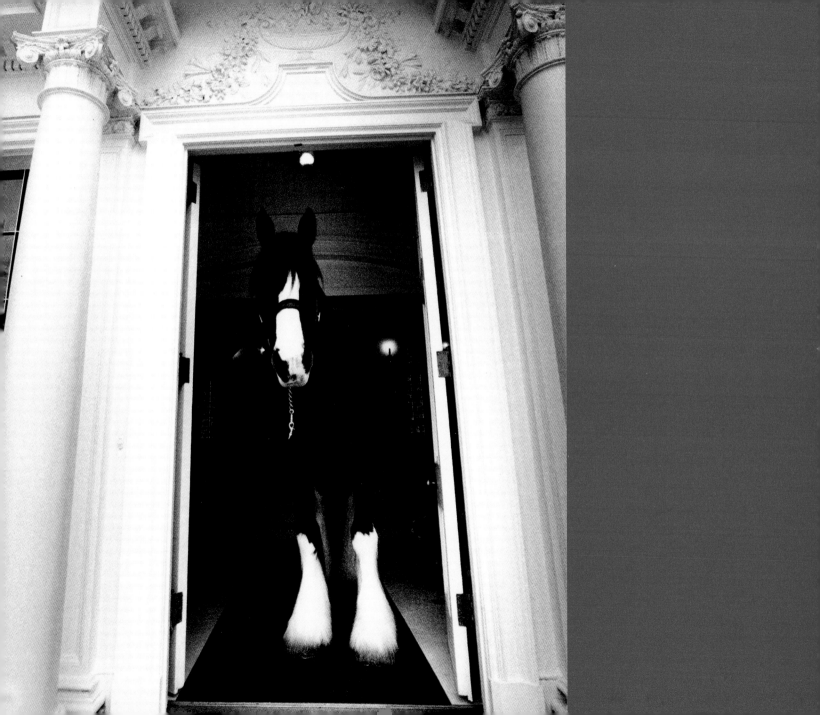

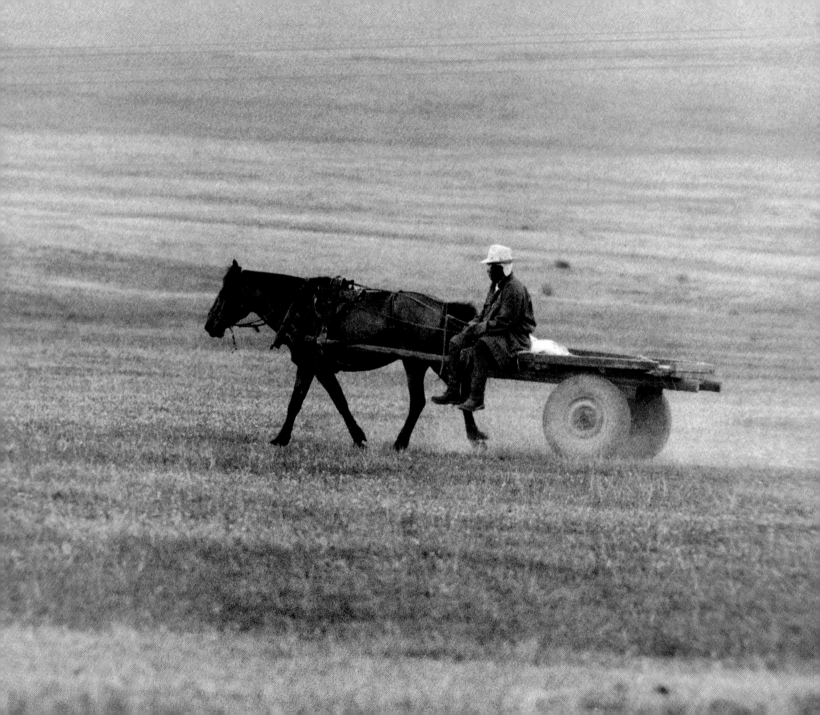

 Simplicity is making the journey of this life with just baggage enough.

—Anonymous

If I only had a little humility, I would be perfect.

—TED TURNER

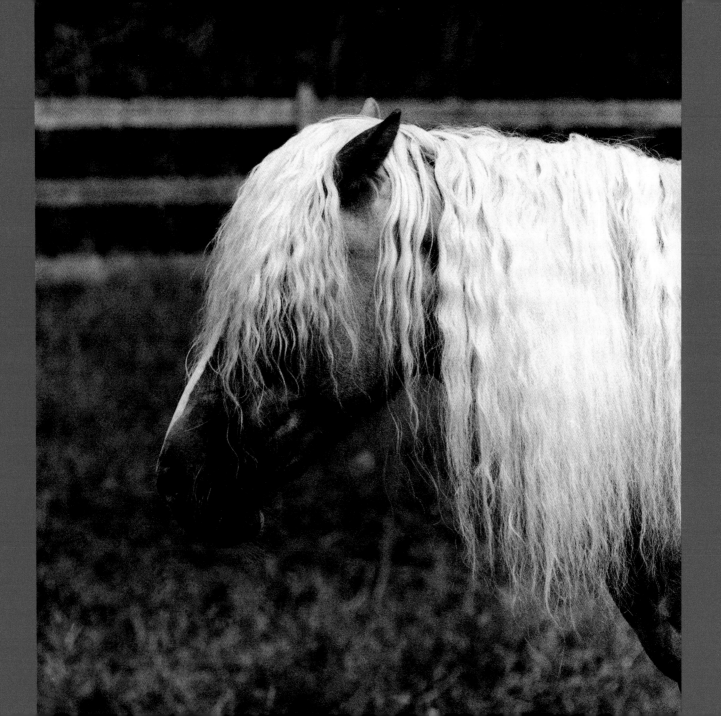

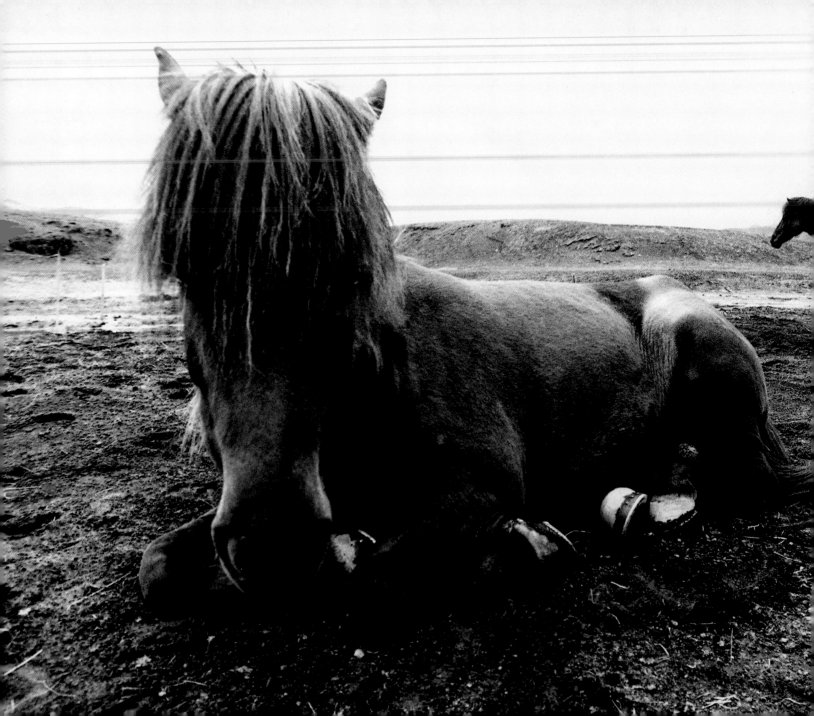

It is better to have loafed and lost
than never to have loafed at all.

—James Thurber

No animal is
inexhaustible as
an excited infant.
—Amy Leslie

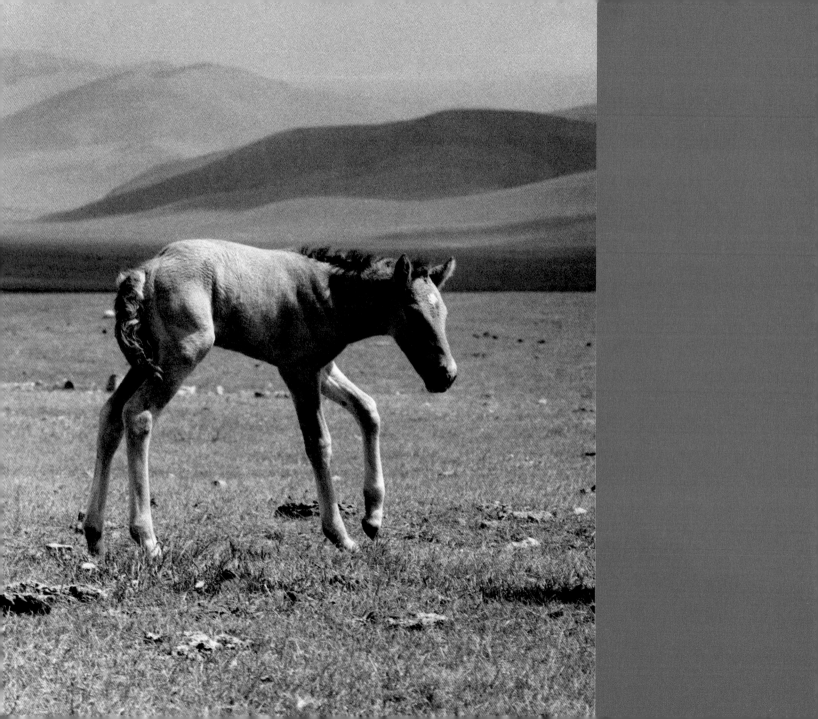

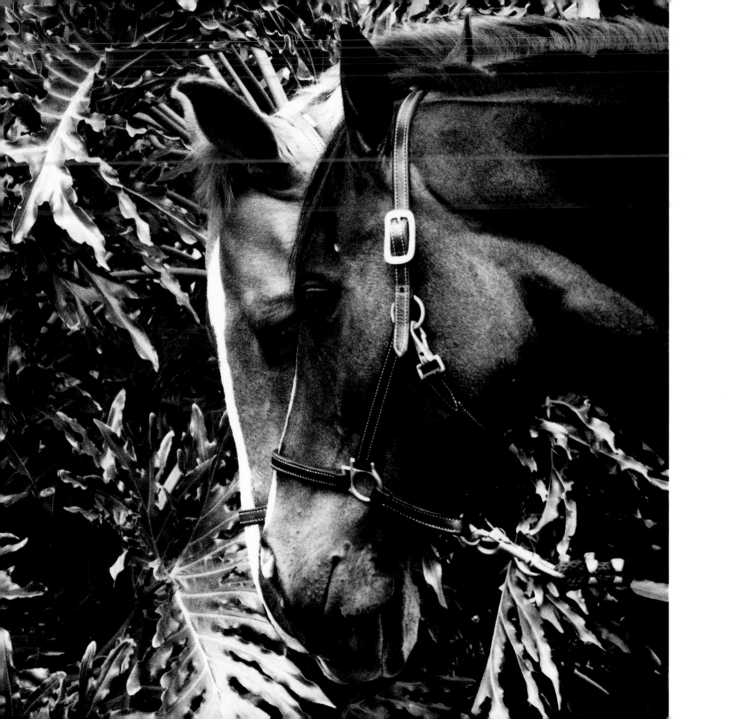

In my friend, I find a second self.

—ISABEL NORTON

Steeds, steeds, what steeds! Has the whirlwind a home in your manes?

—Nikolay Gogol

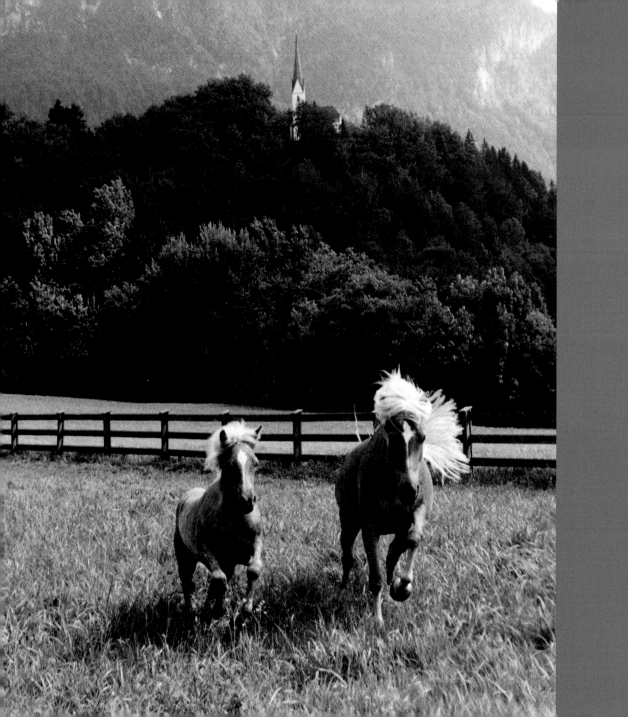

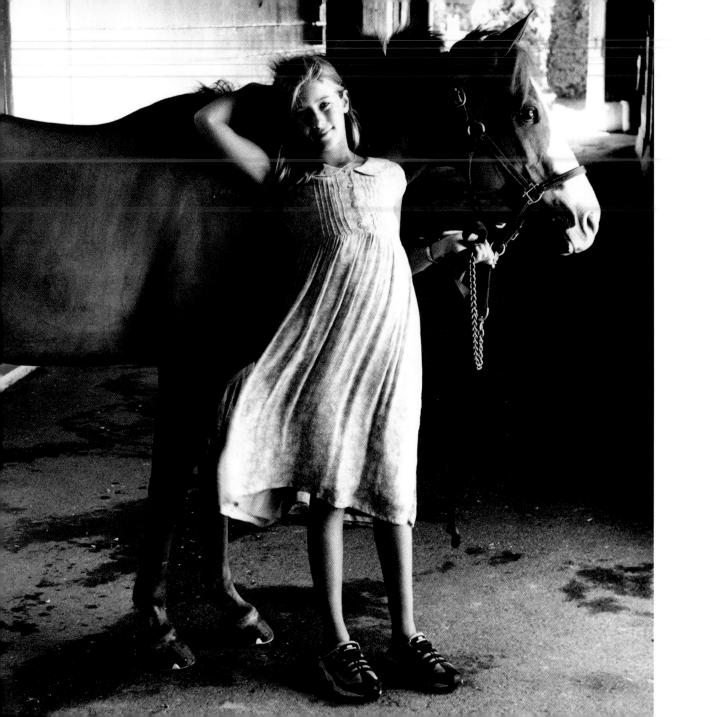

Friendship is a single soul dwelling in two bodies.

—Aristotle

I have enjoyed the happiness of the world; I have lived and loved.

—JOHANN VON SCHILLER

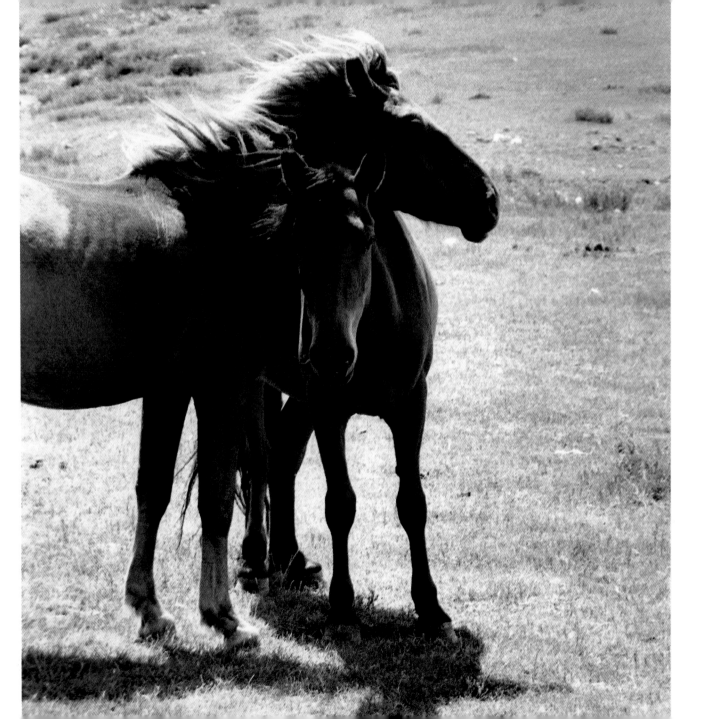

God forbid that I should
go to any heaven in which
there are no horses.

—R. B. Cunninghame Graham

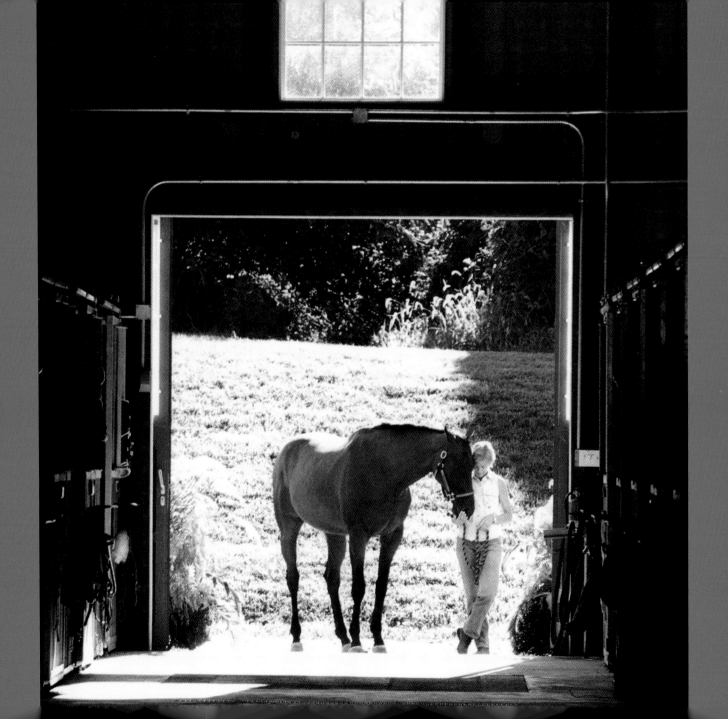

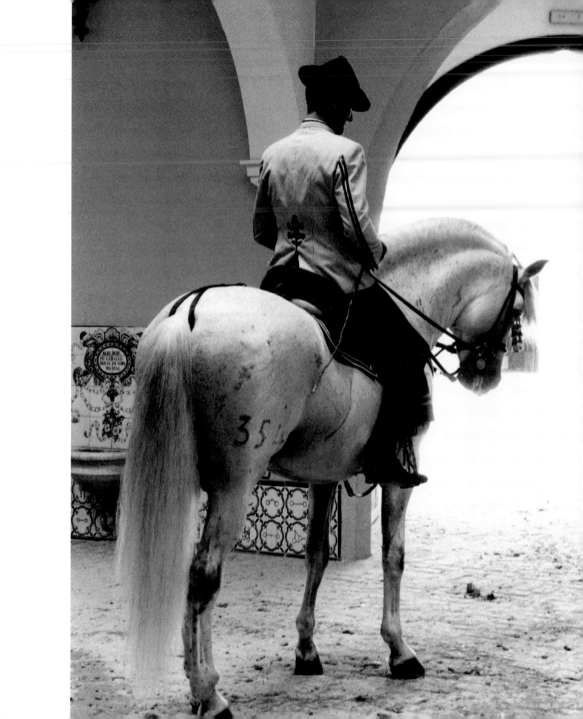

I am not afraid. . . . I was born to do this.

—Joan of Arc

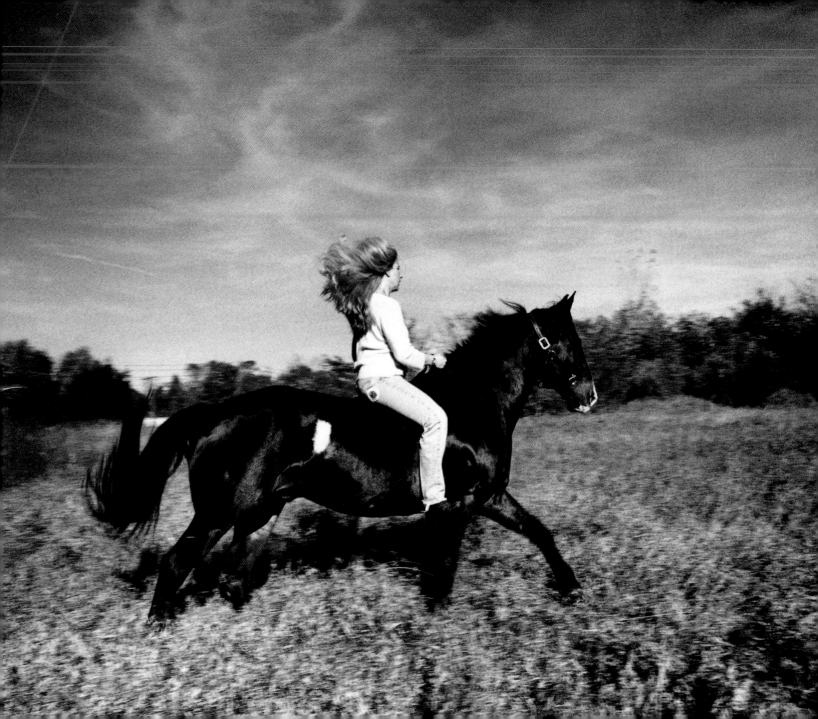

We don't know who we are until we see what we can do.

—Martha Grimes

Perhaps imagination is only intelligence having fun.

—George Scialabra

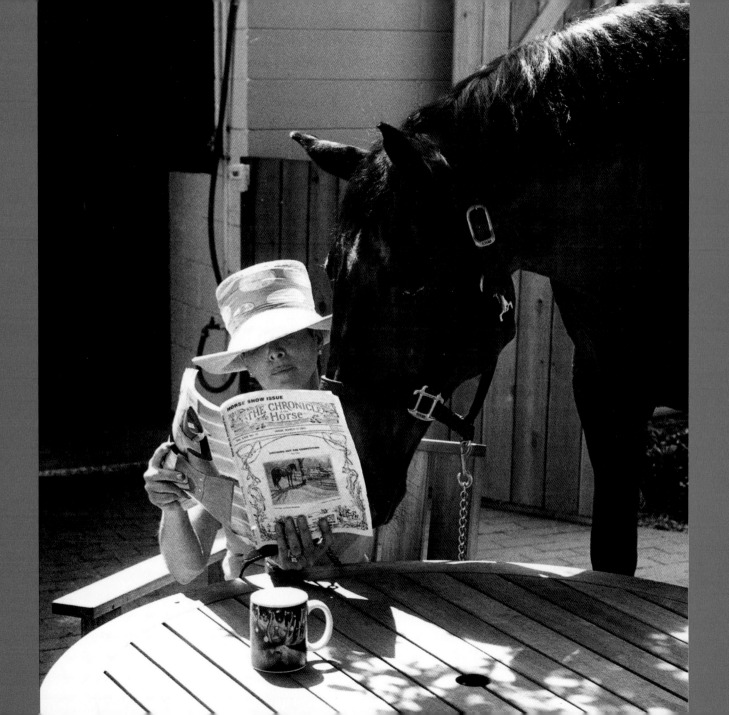

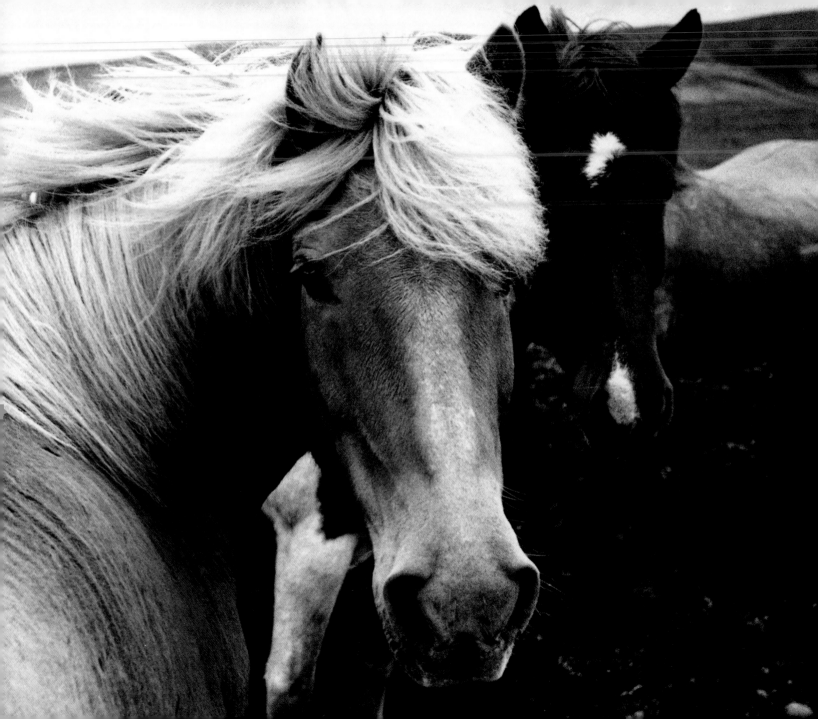

*Constant use had not worn
ragged the fabric of their friendship.*

—Dorothy Parker

You have freedom when you're easy in your harness.

—ROBERT FROST

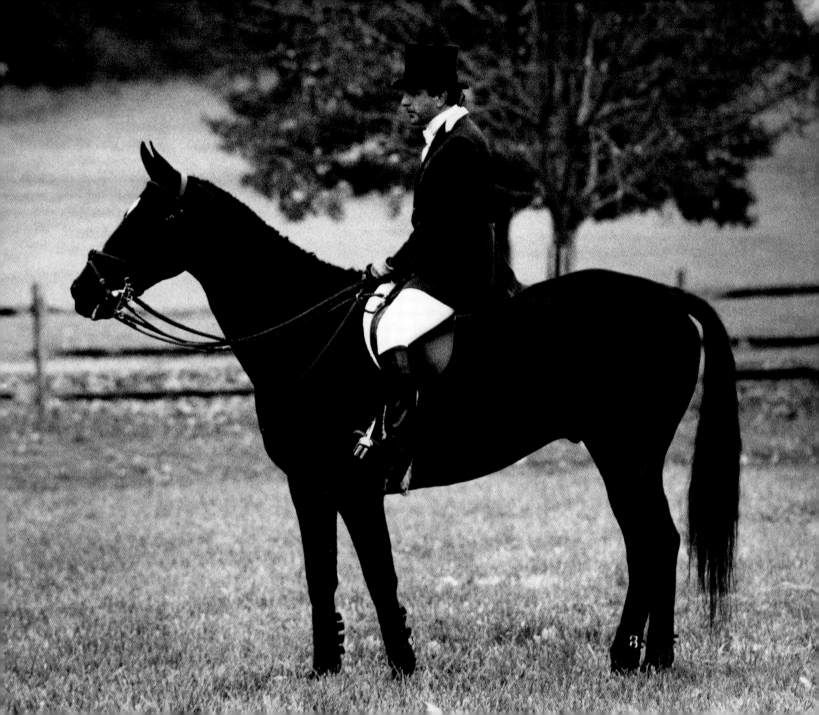

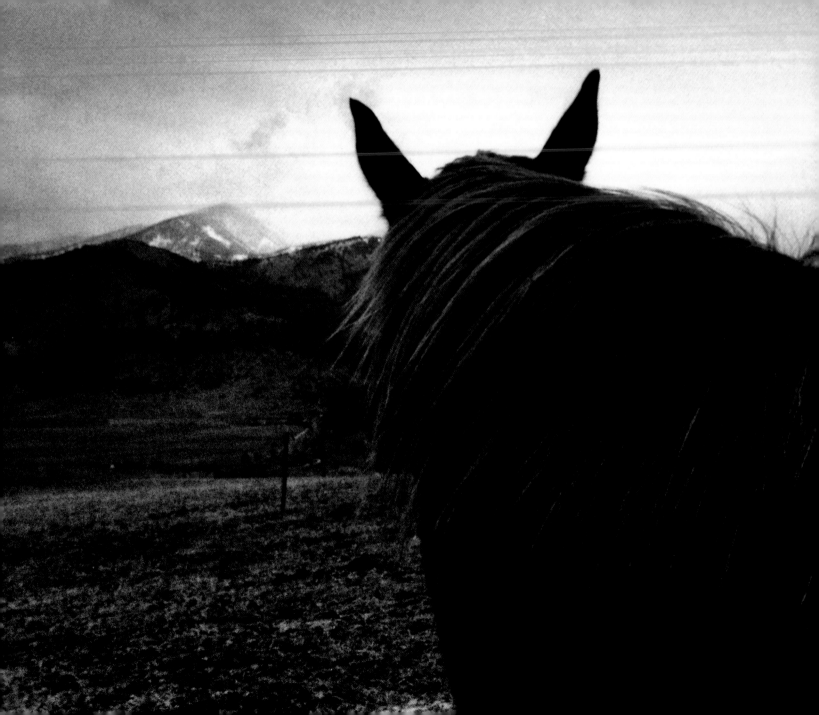

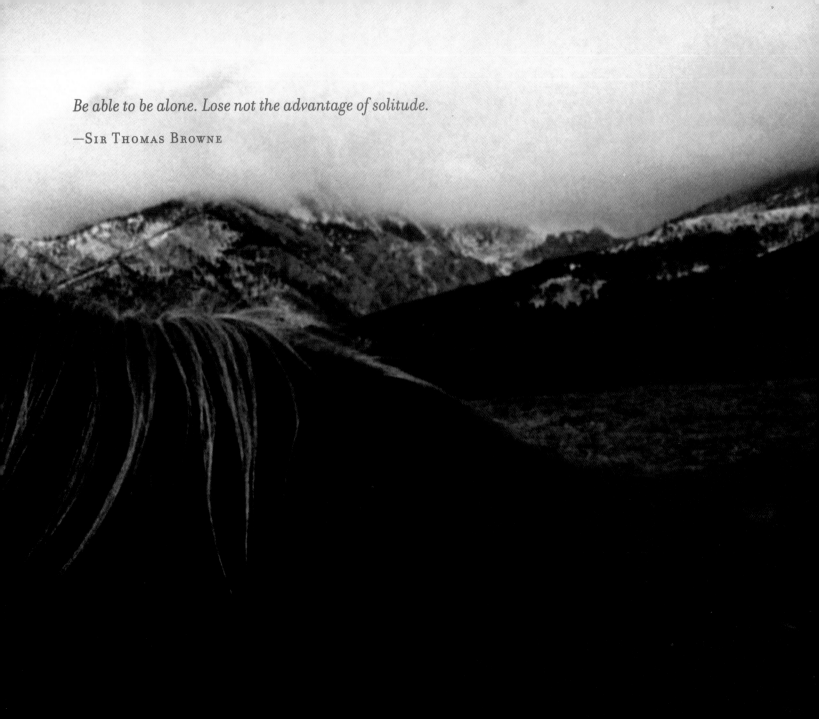

Be able to be alone. Lose not the advantage of solitude.

—Sir Thomas Browne

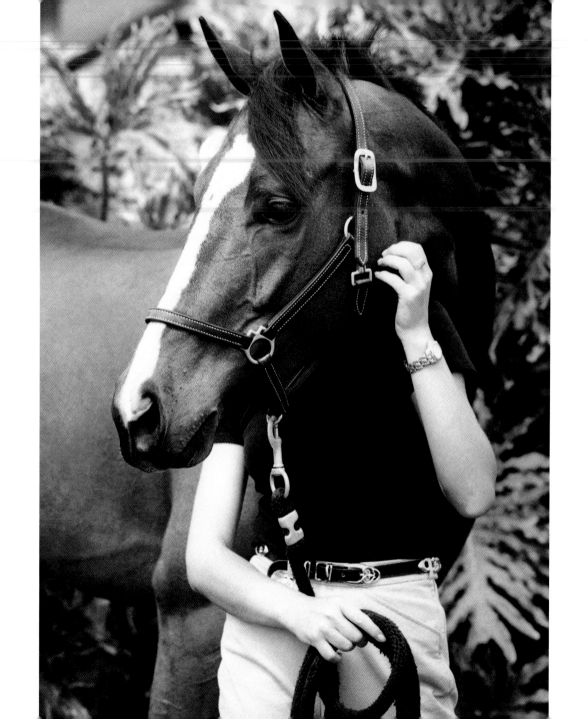

What we love, we shall grow to resemble.

—BERNARD OF CLAIRVAUX

The same fence that shuts others out shuts you in.

—Bill Copeland

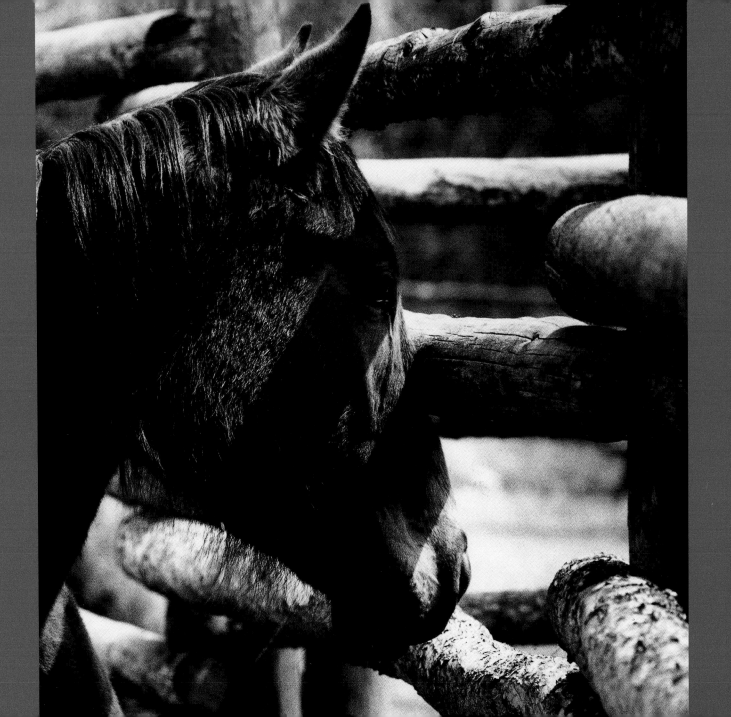

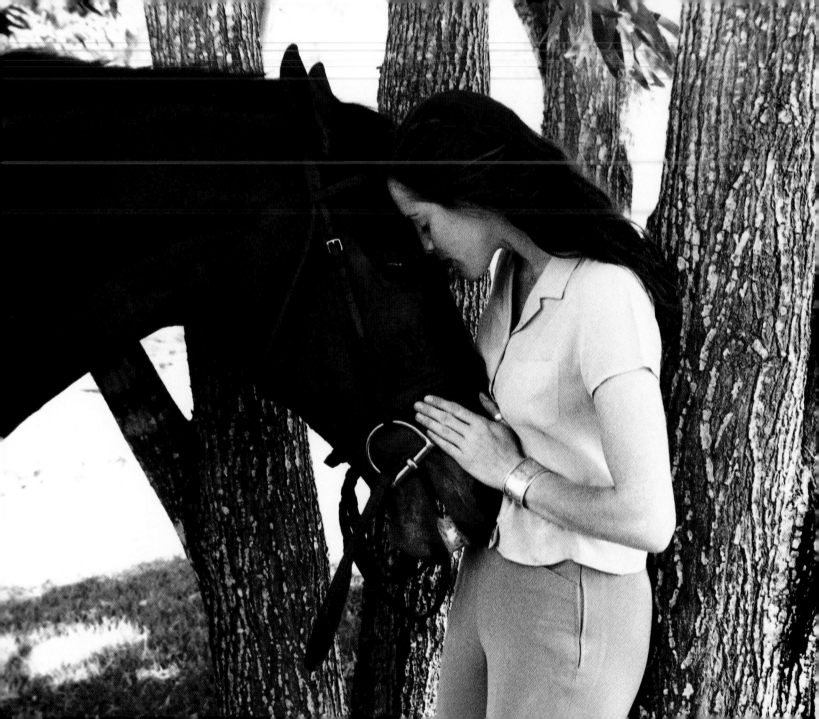

Tenderness is greater
proof of love than the
most passionate of vows.

—Marlene Dietrich

The best and most beautiful things in the world cannot be seen or even touched—they must be felt with the heart.

—HELEN KELLER

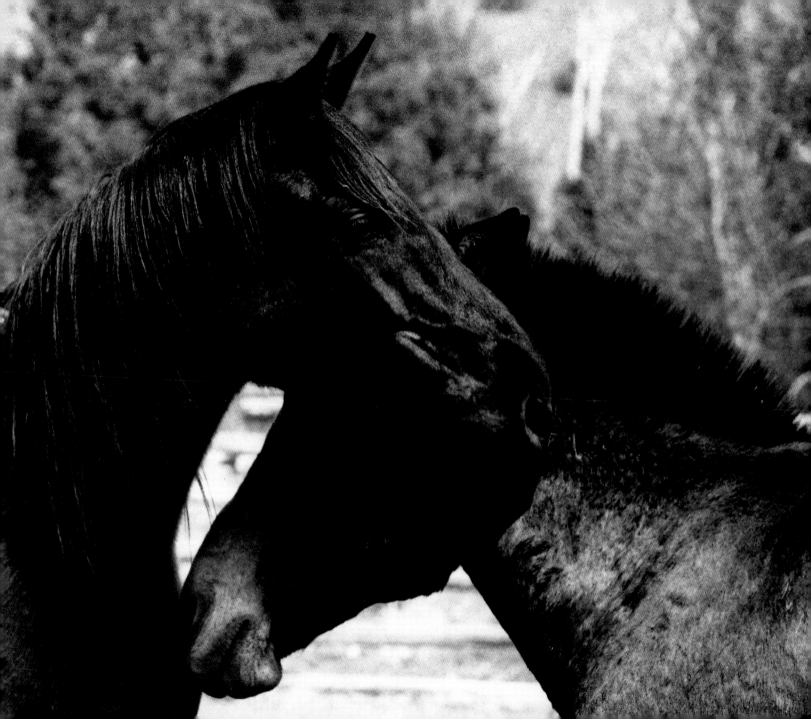

Acknowledgments

I am forever indebted to Amy Creighton for her devotion to this project and her limitless passion for horses. I would also like to acknowledge in appreciation the following people who first introduced me to the equine world: Manda Muller-Kalimian, Steven Price, Sharon McDonald, Kim Tudor, and Jocelyn Sandor.

I would like to thank the team at Clarkson Potter for their stunning design and production effort: Marysarah Quinn, Caitlin Daniels Israel, Trisha Howell, and Alison Forner. To Ronnie Grinberg for her uncanny ability to organize my work when I place a menagerie of images in front of her. To Christopher Pavone, who edits with aplomb. Also to my agent, the incomparable Daniel Greenberg, and the staff at the Levine-Greenberg Agency, who have provided me with an agency extraordinaire, bar none.

I was taught so much about the bonds that exist between different cultures from my hosts in Mongolia, Ochirlantuu Tsend and his family. I appreciate the help Mondiscovery Tours provided in Mongolia and give thanks to Och for being my translator, to Lida Travel for their logistical help, and to Adiya Tsend for pointing me in the right direction.

To Kris White for making Hungary a second home and arranging my extraordinary experience in Hortobagy with the aid of Varga Emese.

For the Montana leg of my trip I want to thank the lovely Pamela Mai Chang and Ted Bryan of Bar None Ranch, Holly Zadra for her hospitality, Eric Foster for his fortitude in the snow, and Jakes Horses and Chuck Kendall of Diamond K Outfitters for their generosity.

Gratitude to Holas Hans-Lothar and Anni Schwaiger of Haflingerstut Fohlenhof Ebbs in Austria.

To Real Escuela Andaluza del Arte Ecuestre and Valerie Chiraussel for allowing me to go behind the scenes of the most amazing display of equine performance I have ever seen. I am forever thankful to Isabel Domecq and the Domecq family for their patience, support, and hospitality.

To Klaus, Judith, and Belle Balkenhol and Guenter Seidel for facilitating one of my favorite images. I cannot thank Lisa Wilcox enough for taking the time to help me navigate through Europe's equine terrain. You are a champion to me on every level! A thank you to the entire U.S. Equestrian Dressage Team. What an honor to observe your skilled horsemanship up close and have the pleasure to spend time with you over dinner.

To Hekluhsestar's amazing Icelandic horse expeditions and the absolute kindness of Nicole, Jon, and Karin for allowing me to be a part of an awe-inspiring experience, following their team of riders.

Warm embraces to the American Vaulting Association Friendship Team and a special thank you to Jan Weber, Del Dyer, Lucinda Faulkner, and Kerith Lemon for their participation in this project. I am inspired by this exhilarating equine discipline you offer all of us.

For their assistance: Pat at Equitours; Marilyn Adams, director of Dressage/USET; Emilio Cassinello, Consul General of Spain; Julia Nowak; Joelle Richard; Charee Adams and the American Trakehner Association; the Saratoga Race Track; the two Nancys of The Oxridge Horse Show; Jane Golden, Winter Equestrian Festival; Dominion Saddlery; the Los Angeles Equestrian Center; and Tony Hitchcock, his dazzling wife Jean Lindgren, and the Hampton Classic. To Donald Williams for his rock of Gibraltar–like constant support.

To the Petography™ home team of helpers. To the unrivaled Andrea Moore, for her office management that keeps us at the top of our game. And to my assistants: Brooke, Catherine and David. You three have made the past year full of wonder. (Although next time, David, I hope you stay in the paddock when trouble rears its ugly hoof.)

Finally, to all of the humans and horse owners without whose participation my imagery would sorely lack the spark you provided.